Date Due

MAY 0 4 1999		
MAY 1 1 1999		
MAY 1 3 1999		
JUN 0 3 1999		
SEP 14 MAR 5		
OCT 23 APR 5		
NOV 25		
DEC 18		
APR 20		
JAN 23		
MAR 27		
FEB 8		
FEB 8		

BRODART Cat. No. 23 233 Printed in U.S.A.

Northern Exposures

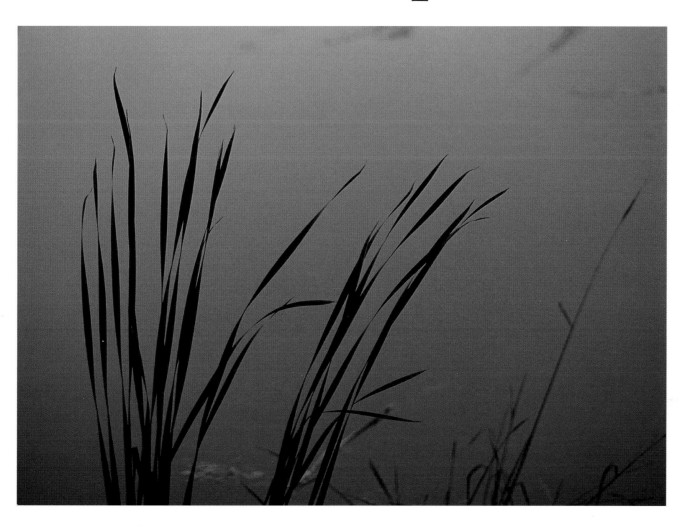

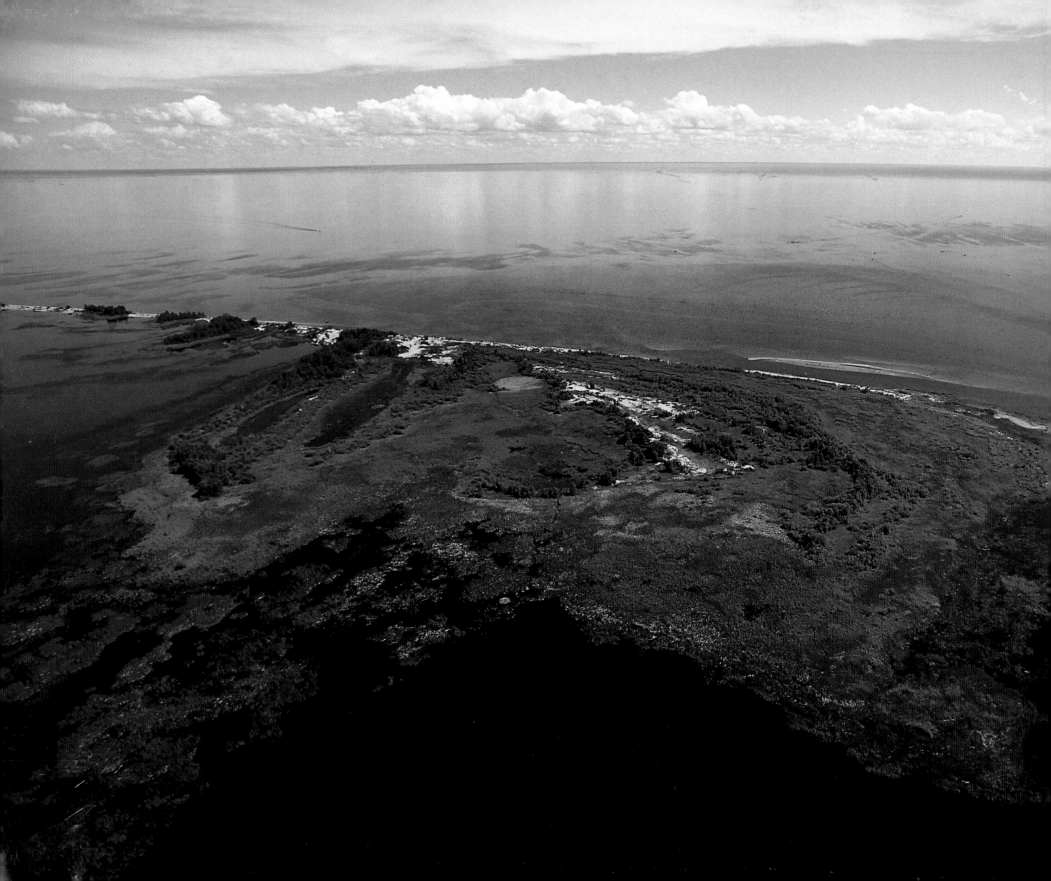

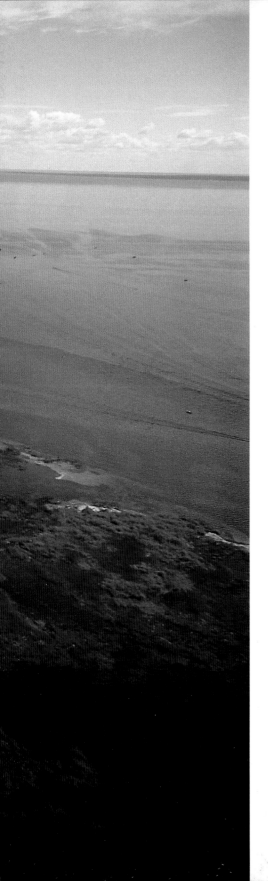

Images of Northern Ontario

Photographs by

TOM THOMSON

Published in 1998 by
Tom Thomson Photography
Box 852, Keewatin, Ontario, Canada P0X 1C0
Tel. (807) 547-2930 Fax (807) 547-3098
e-mail: tomthomson@voyageur.ca

Distributed in Canada by
Turnstone Press
607-100 Arthur Street
Winnipeg, Manitoba, Canada R3B 1H3
Tel. (204) 947-1555 Fax (204) 942-1555
e-mail: editor@TurnstonePress.mb.ca

Cataloguing in Publication Data is available
from the National Library of Canada

ISBN 1-55056-580-X

Designed by Daryl Nikkel
Stories by Pamella Baxter

Printed and bound in Canada
by Friesens, Altona, Manitoba

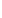

Dock at misty sunrise

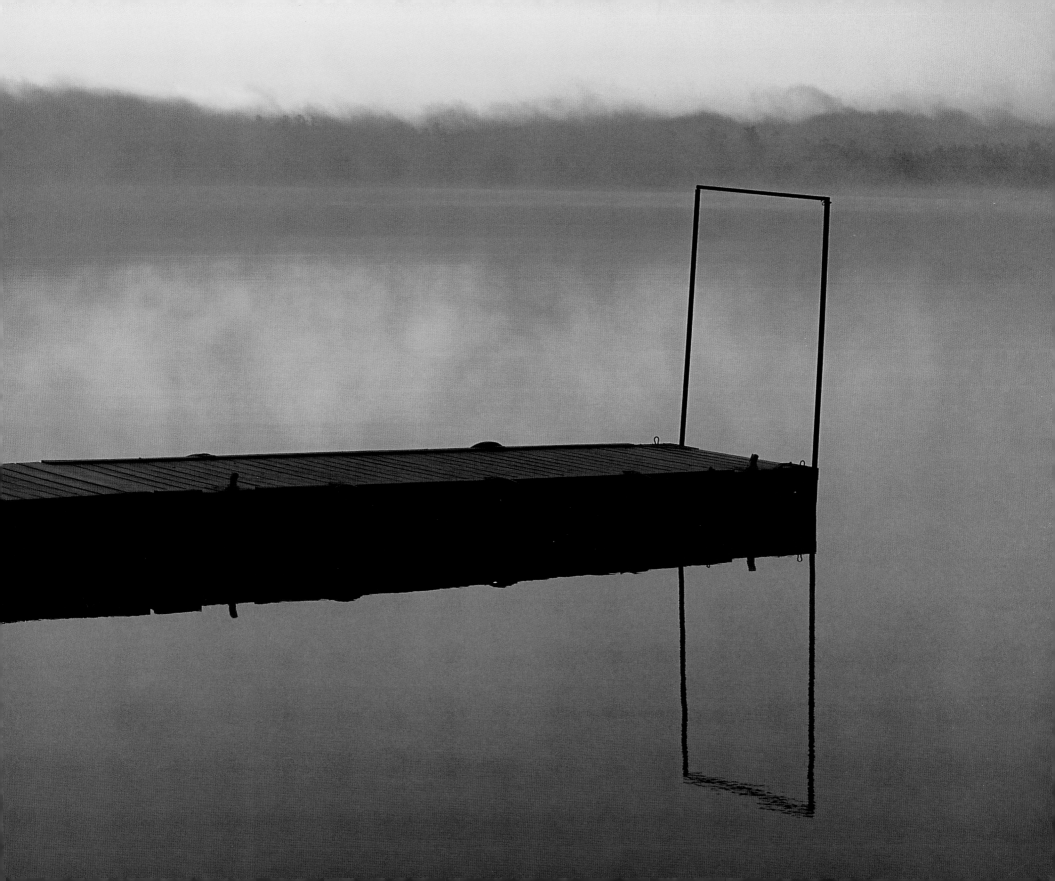

For my parents Tom & Margaret Thomson

Who first gave me roots,
then gave me wings.

CONTENTS

Whitetail deer peering through the underbrush

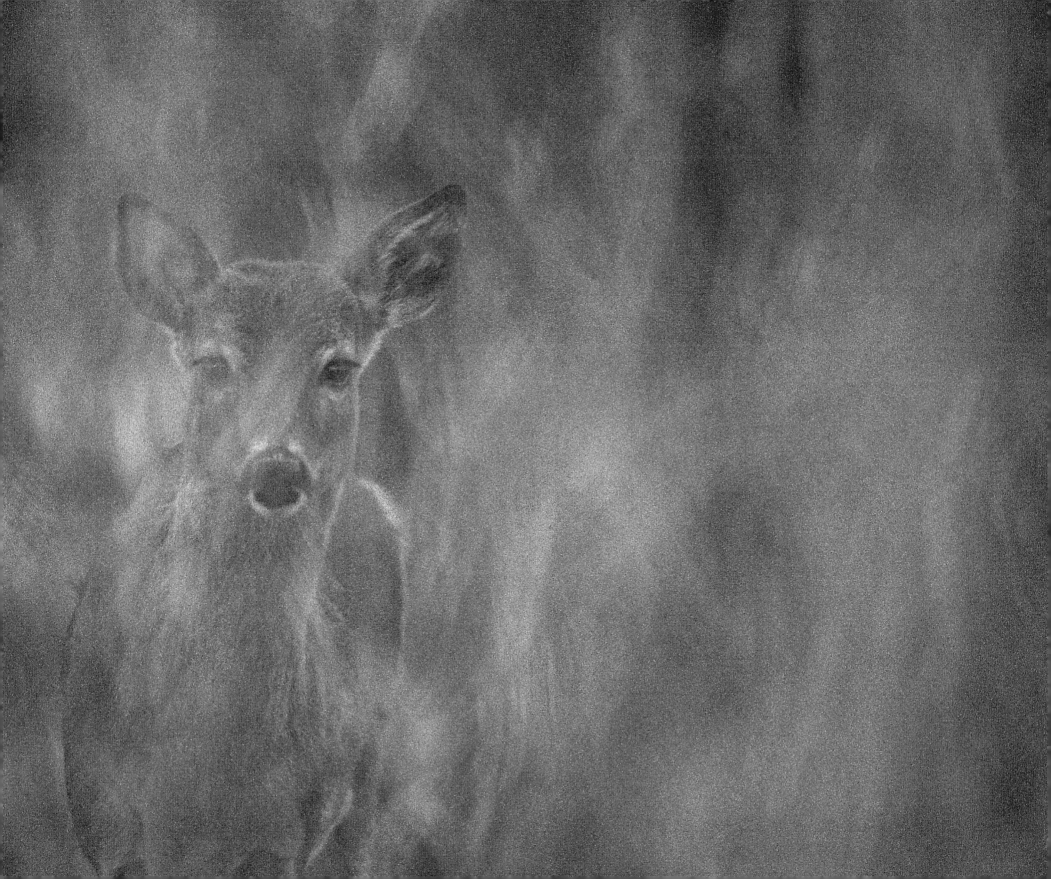

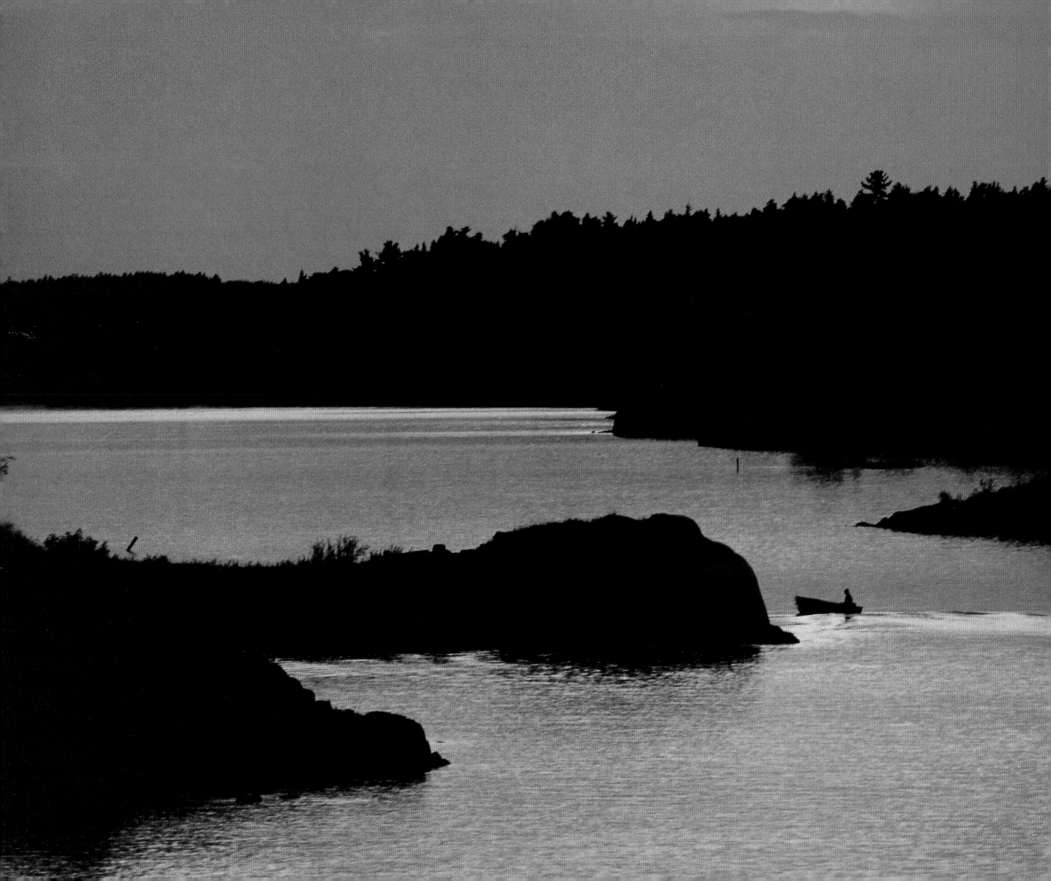

FOREWORD

There are places in this vast land
that call to your very soul.
Northern Ontario has called to me
all my life,
learning and living in harmony with
nature's rhythms and changing seasons.

I am fortunate to live where I can
fish in an unspoiled wilderness,
watch the sunlight dance on the water
and raise a family under crimson skies.

This is indeed a special place,
one that continues to call to me,
one that I call home,
one that I shall never leave.

Tom Thomson Sr.

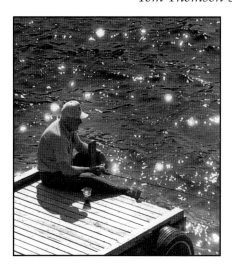

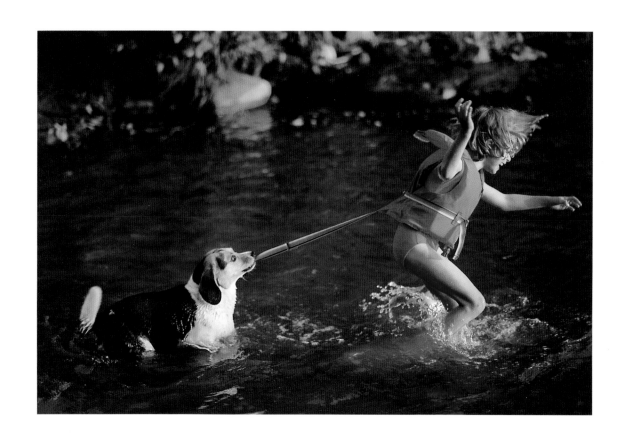

ACKNOWLEDGEMENTS

A book of this nature does not just happen.
It takes months of planning, a team of dedicated professionals and the support of corporate sponsors and friends.

The generous financial support of **Bayview Toyota** has been a tremendous help. The quality of workmanship in these vehicles really shows when you are riding over the ever-surprising terrain of the North; talk about testing your shock absorbers! The testing site for Toyota must look somewhat similar to this area. Thanks especially to Don Brown for having the foresight to support this project.

Using **Canon** camera equipment exclusively, I can attest to the dependability of it. My camera equipment is a part of me, I know it intimately. The equipment takes an incredible amount of abuse climbing in and out of boats and vehicles in often unfriendly weather and yet continues to be an extension of my sight with perfect precision. The high quality of these products means they are almost never in need of servicing and should the need arise it is always readily available. Canon has earned their impeccable reputation among professional and amateur photographers alike. Their generous contribution of equipment is sincerely appreciated.

Voyageur Net's internet and website support has been significant. These people are top-notch and have provided this area with the benefit of their depth of technological "know-how". E-mail has been such a valuable tool to keep in touch with the office, news editors, and photo desks while out on the road; I can transmit photos from anywhere. I thank the people at Voyageur for putting up with my frequent phone calls. Our website has been a great way for people to find out more about us and "Northern Exposures", we feel connected with the world. When researching for the book, the internet provided us with a wealth of information. We are still awed by the number of visitors to our site every day and the e-mails we receive.

To **Kenora 1/2 Hour Photo**, Chuck Bond and his staff, whom have been so patient and generous in the past and graciously agreed to support the book; sincere thanks. My schedule is radical at times, and because of time constraints while on news assignments, I frequently have required negatives or prints in less than half an hour, they are always accommodating . Photo Editors have often stressed that "nothing is older than old news" and thanks to the people at 1/2 hour photo; I have never missed a deadline ("deadline" should be a four letter word).

I owe a huge debt of gratitude to

Bruce Henderson who crunches the numbers and keeps my life in order.
Daryl Nikkel brought to the project his creativity; combining photographs and text in arresting layouts and visual concepts.
Pam Baxter provided the human element and intuitiveness in her writing , she was an inspiration to us all.
Jon Ouellette for being a true friend and a strong supporter of my work.
Dave Van Dam has been behind this book from day one and continues to provide valuable advice.
Jim Johansen who has recognized and promoted local talent over the years.
Special thanks must go to *Stan, Gail and Rose* at CSP Print and Marketing for their assistance and input.

I am grateful to the people who helped in my career
Ottmar Bierwagon , my agent
Jon Thordarson who taught me the intricacies of photography
Dave Cooper of the Toronto Star
Walter Kaiser of Custom Images

There have been many individuals who have contributed to this and other projects and although I am sure I have missed some of you, you know who you are:
Dick Fahlman, Dave Burt, Mark Duggan, Tom Moloney, Paul Jones, Paul Leischow, Jim Mosher, Chuck Bond, Brad Henderson, John & Joanne Saunders, Tracey Wood, Jim Blight, Jim Haggarty, and Bob Godfrey.

Thanks to my wife Joelle, who has unconditionally supported and believed in my abilities. To Sean, Daryl and Bailey, who keep my feet firmly grounded and sometimes are my only reason for getting out of bed in the morning, 'cause they're so noisy . . . you guys are great!

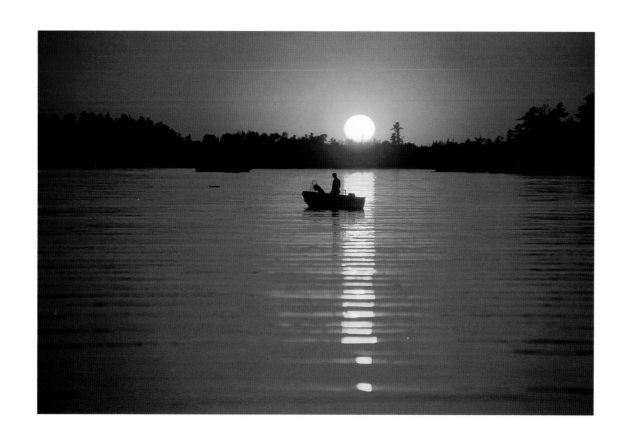

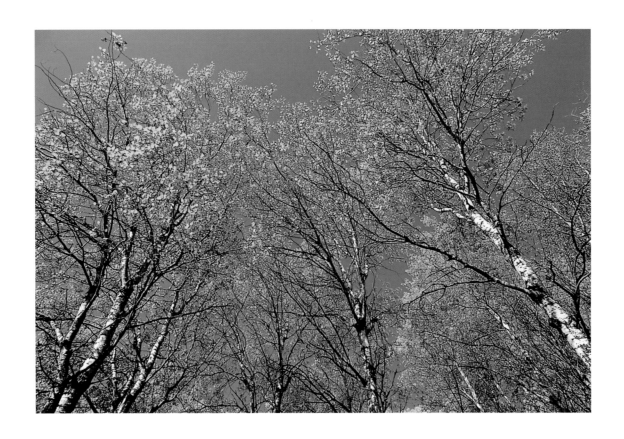

Images of Northern Ontario

Northern Ontario's terrain includes extreme diversity, from deep cold water lakes to scattered shallow wetlands, rocky hills and cliffs that seemingly spring up from nowhere exposing the face of our Canadian Shield. Wildlife abounds in this land of natural camouflage as does plant life which is evident in our dense forests, with a blanket of green ground cover and magnificent tall pines, spruce, and balsam.

The first european explorers arriving here in the 1800's did not have an easy task ahead of them. Their intent was to find a shorter trade route to the pacific so as to fill the rising demand for furs in Europe. Once the route was established, the fur trade in this area provided a healthy income for many until the 1880's when demand dwindled.

The Hudson's Bay Company was largely responsible for establishing posts along the trade route. Many of the locations where these posts existed gradually developed into self-sustaining towns before the downfall of the fur trade and are thriving towns and cities today, thanks to other industries such as logging, pulp and paper, mining, and tourism.

Though parts of Northern Ontario are quite populated, you are never very far from the serene, awe inspiring beauty of nature. Maybe that is why over one million people visit here every year; or maybe it's the fishing, or the skiing. . . everyone has their own reasons; but we all share the appreciation of one of the most naturally beautiful areas on this continent.

Everyone has their own memories of Northern Ontario.

In this book I have attempted to create a "biography" of sorts with the images of what I take away from the northern experience. I invite you to share in a selection of my views and feelings of this God given land of plenty.

These are . . . *Northern Exposures*.

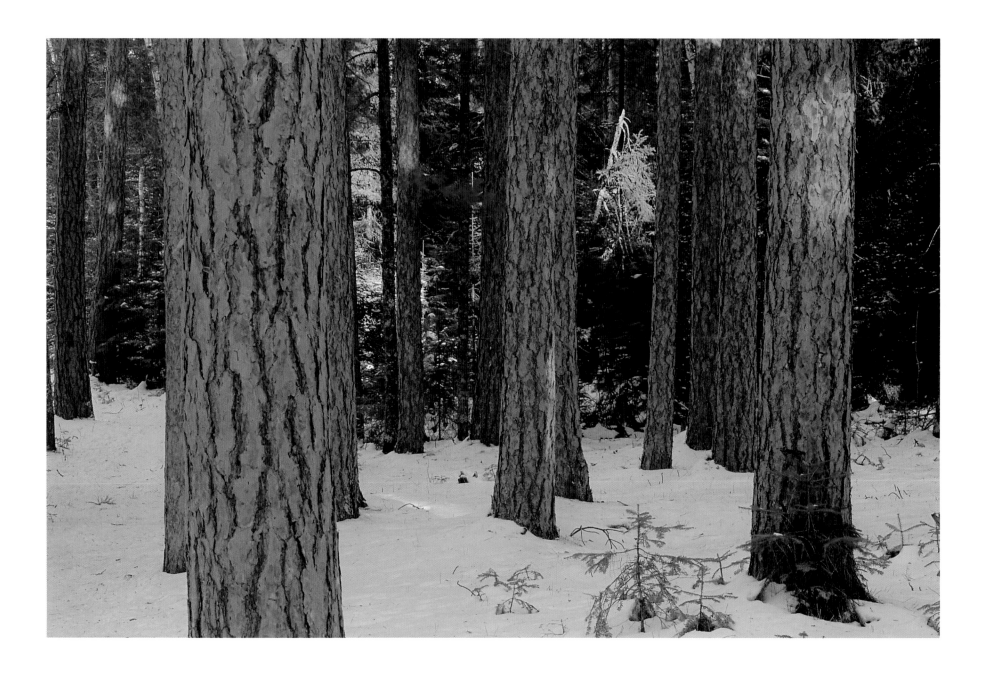

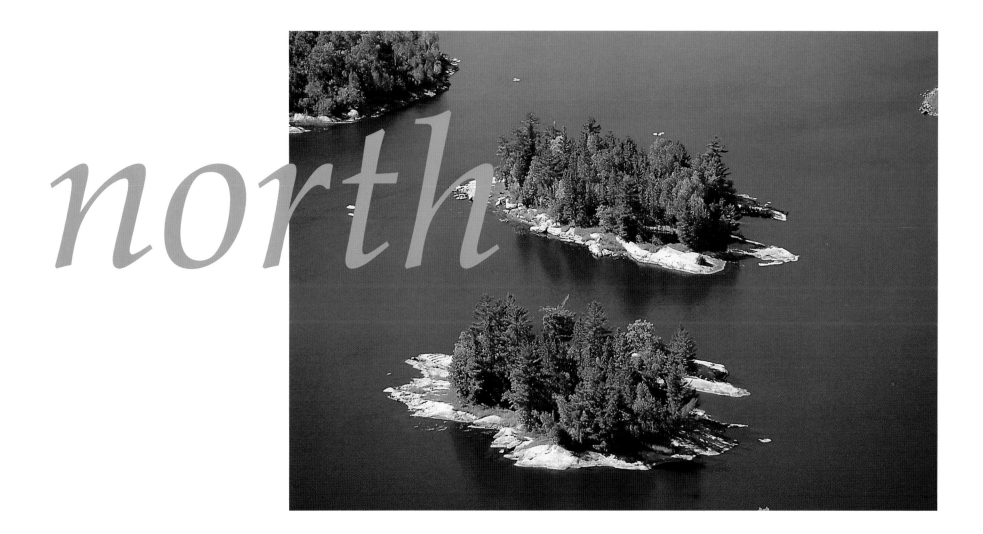

north

The human species whom choose to call our North home are a resilient breed. We have changed the very definition of water sports. Snowmachining, snowshoeing, cross-country (or "cross-lake") skiing, boating and of course fishing, more fishing and ice-fishing, are just a few of the ways we have come up with to combat cabin fever. We northerners spend as much time outdoors as we possibly can; our summers are filled with hot, sunny days that make working inside a terrible punishment. Most who live here would probably agree that there is something deeply satisfying about spending a day out in the elements, (whether working or playing) then coming home, enjoying a meal with family or friends, and perhaps a sunset.

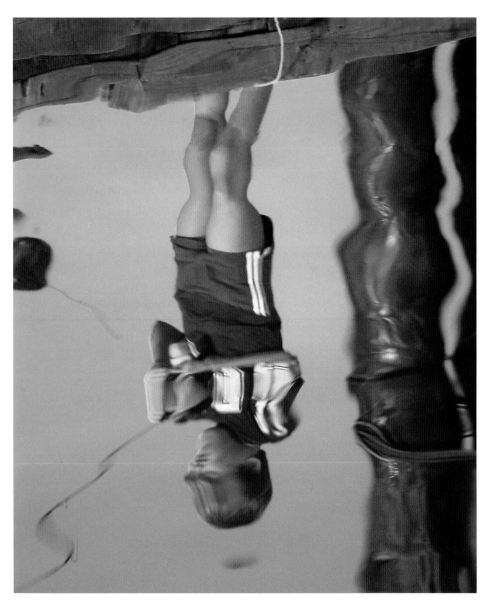

Sitting on a dock early in the morning sipping on a fresh cup of coffee, looking out onto the water, feeling the soft rocking motion of the water seems to make all your cares float away. Perhaps these feelings come from our desire to get back to the basics, be at one with nature. Taking the time to admire nature, the hues of colour she has painted for us, and each animal we see can turn a walk or hike into an amazing adventure, allowing us to appreciate these animals for the masterpieces they really are. Ultimately we as humans do want to protect and preserve nature because we are after all, a part of it.

Getting up early is not easy for me, but sometimes, when I crowbar myself out of the bed it pays off. Up until this particular morning, I had all kinds of spider web pictures (not that I go out of my way to shoot them) all of which at best came close to being what I was looking for. It is interesting to see all these webs spotted with dew early in the morning and then see them all destroyed by the wind shortly after. The spiders are certainly more tenacious than I am early in the A.M.

It was interesting to watch this young boy so immersed in his fishing. As I watched his reflection create all these neat patterns for my camera I realized I had been so immersed myself that more than an hour had passed.

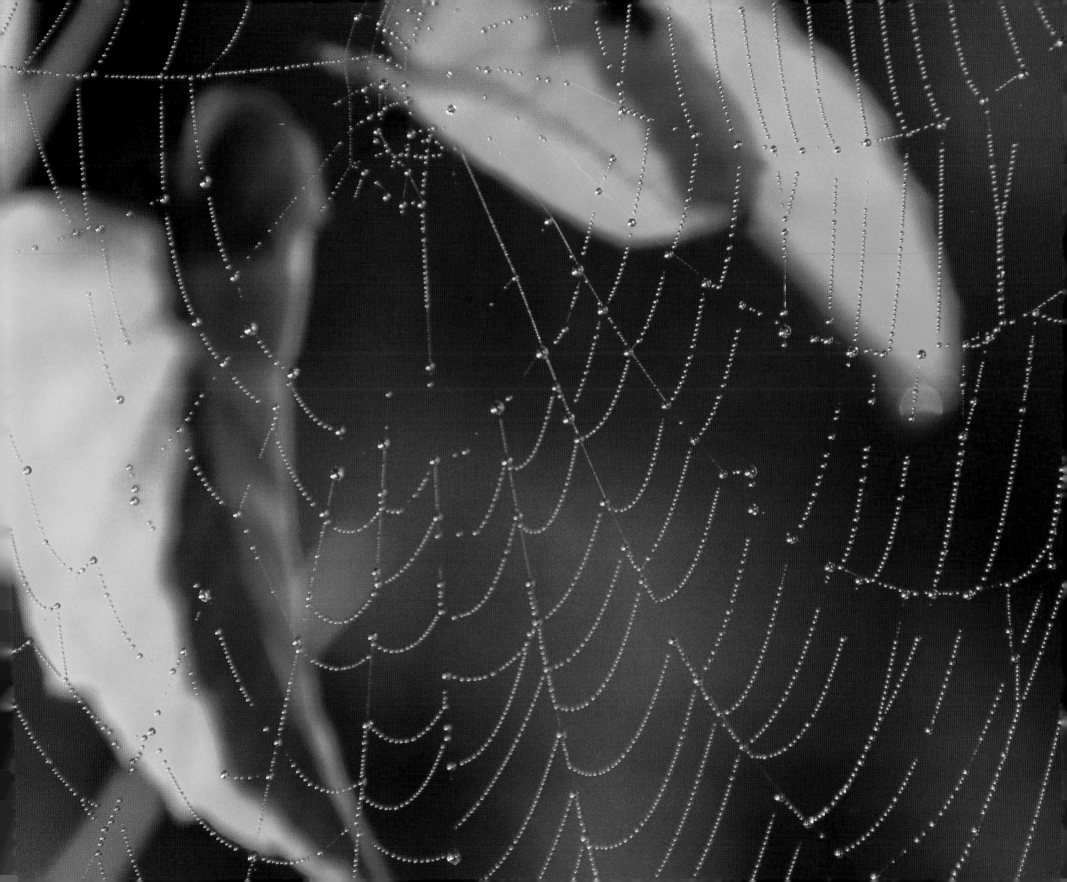

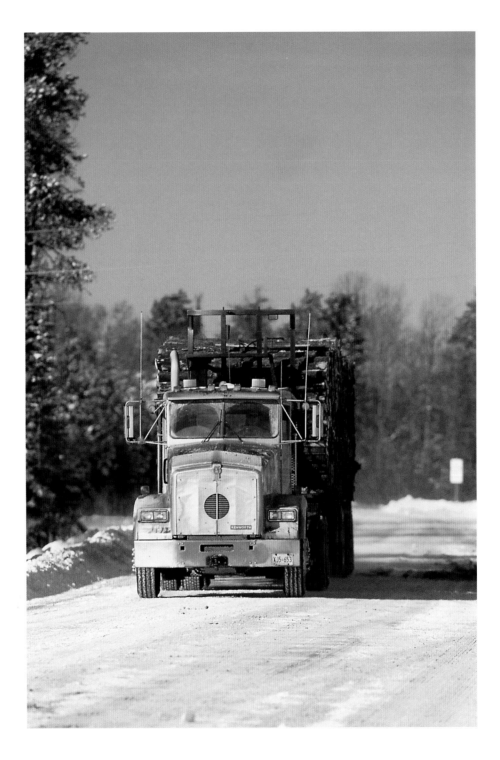

Hauling logs to the various mills in Northern Ontario can be a bit of a challenge when the dirt roads become an endless ribbon of ice and snow.

wild

The abundance of unspoiled wilderness in Ontario's North makes it a perfect haven for the thousands of animal species who call it home. Although they have had to adapt to the long, sometimes bitterly cold winters and summers which are often hot and humid, they have done so with amazing resilience. The endless untouched forests with misty mornings and moonlit nights have provided a decent camouflage for those creatures whose survival depends on it.

A harrier jet with feathers drops in on all the activity atop a small island near a fishing lodge. To get its share of the fish guts put there by the guides after cleaning the days catch this eagle had to compete with 10 other eagles and a large collection of gulls. The guests would all sit on big deck chairs and watch the competition until the sun set.

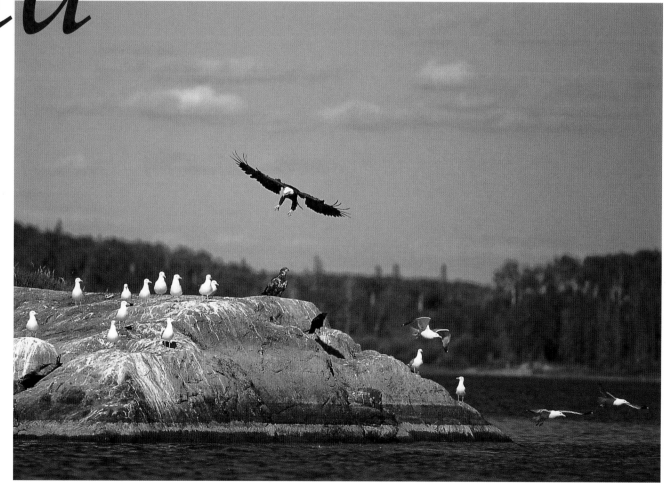

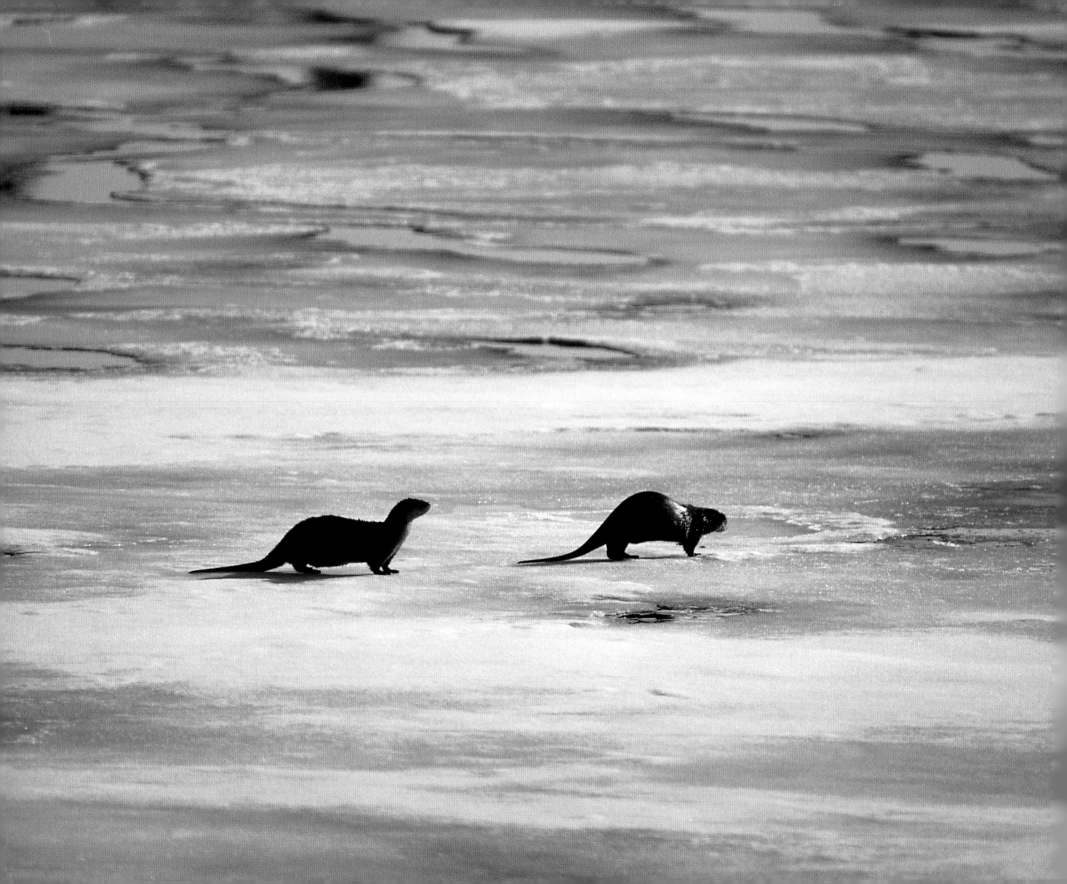

Otters are just kids at heart no matter what age they are. I have sat and watched them for hours on end and even when they're going about the serious business of gathering food, they really seem to make a game of it. This picture shows them in their environment with an infinite array of holes in the ice for a never-ending game of hide and seek. . .What a life.

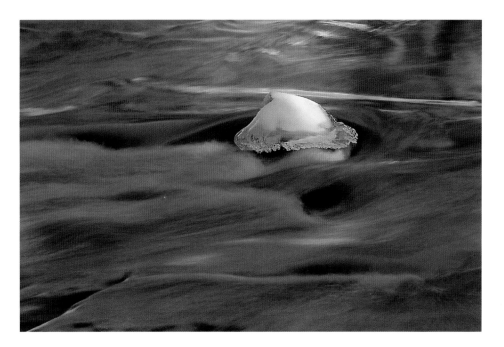

People sometimes wonder what I'm doing when I shoot pictures. A friend was with me when I shot this image and for the life of him couldn't understand why I would want a picture of this ice. By using a slow shutter speed to blur the fast moving water and leaving the ice sharp, I hoped it would take on an impressionistic painted quality.

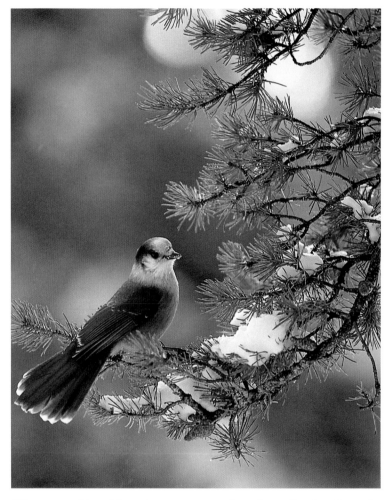

The campsite robber is a name used to describe the Canada Jay or Whiskey Jack. Knowing their penchant for making off with anything left unguarded, I placed a small piece of the granola bar I had been chewing on amongst the branches of this backlit pine. The hard part was getting back to the camera before they took off with my lunch.

Our native flora usually provides a veritable cornucopia of food for the vegetarian wildlife population. These vegetarians themselves, unfortunately provide a variable menu for others. The cloven hoof prints of a deer in the freshly fallen snow followed by the unmistakable paw prints of a wolf tell the story of just how untamed our wilderness remains. Predators must labor for a meal; giving chase over hilly, rocky miles can be no easy feat. Some may consider the terrain in Northern Ontario unfriendly, but to the mammals who have lived and thrived here for centuries it is their friend because it is not easily accessible to humans. The sheer numbers of species here boggle the mind; from Deer Mice to Martins, and Moose, we really do have it all.

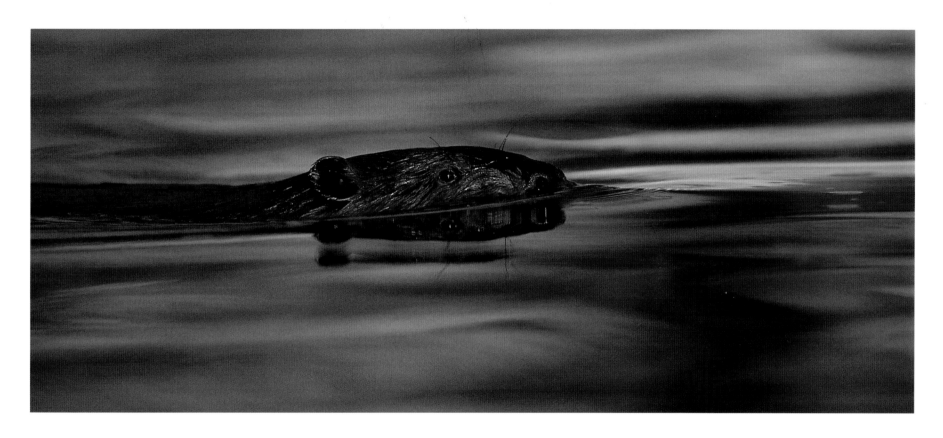

Not easily distracted from its work the beaver is however always alert to potential threats, keeping its eyes and ears open to the sights and sounds of danger. When approaching beaver you will soon know that you have come too close, a slap of its tail on the water to warn the others and it's gone. When building its house the beaver will always have multiple exits in case of the need for a hasty retreat.

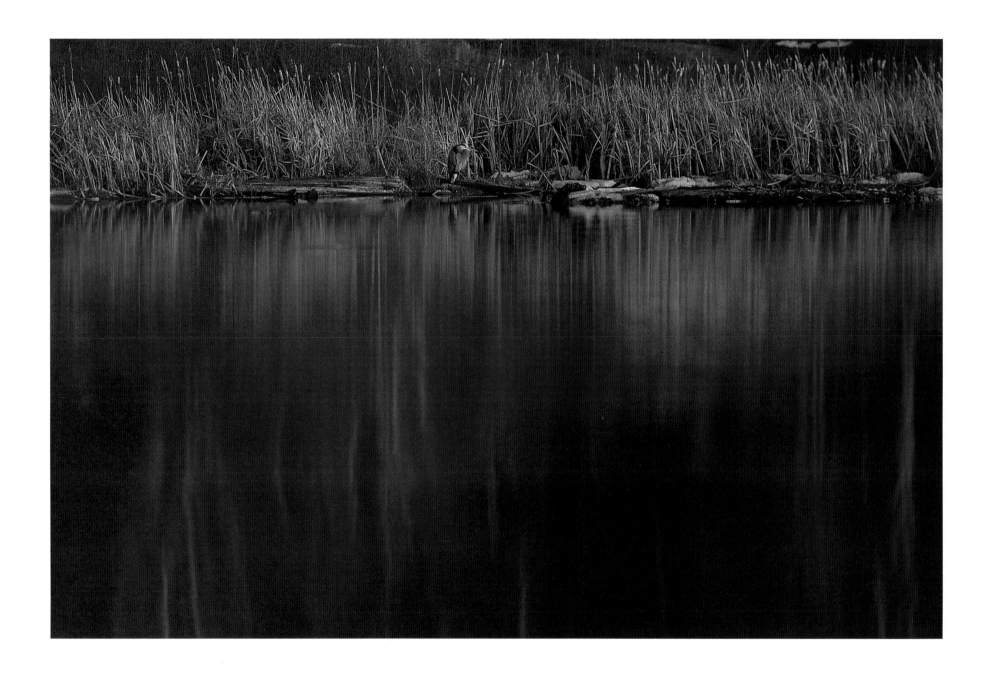

Hiding in its environment this blue heron sits in wait for its dinner. Getting close to these hunters of fish is sometimes a daunting task because they don't seem to like a human presence. When watching them catch their prey, it is a case of long periods of boredom punctuated by a split second of action, when they finally grab a fish.

Wading through a swamp for its dinner, this bull moose is master of its domain. Some bulls can exceed 1/2 ton and are a very popular prey for big game hunters. The bulls are generally solitary animals but this changes during rutting season when competition for mates can cause fierce fighting amongst these powerful males.

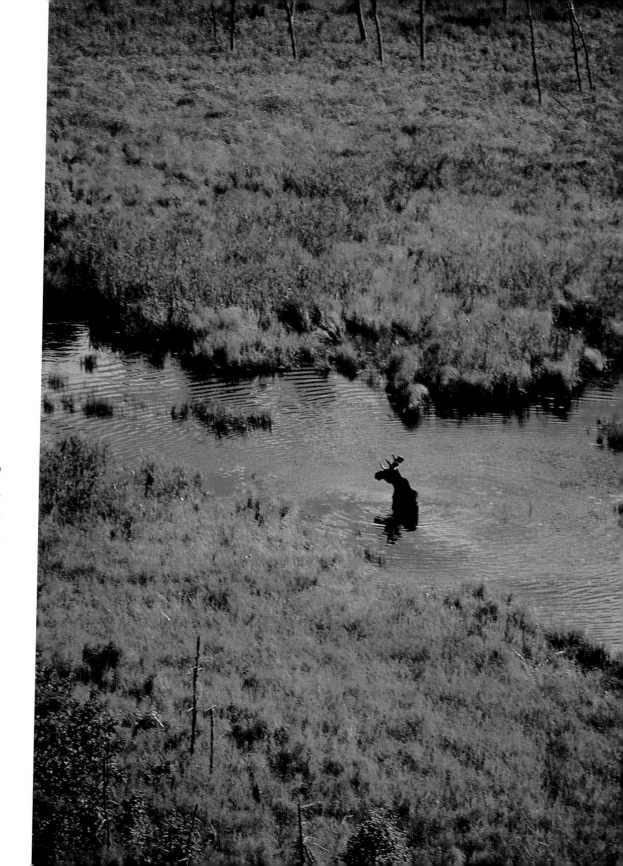

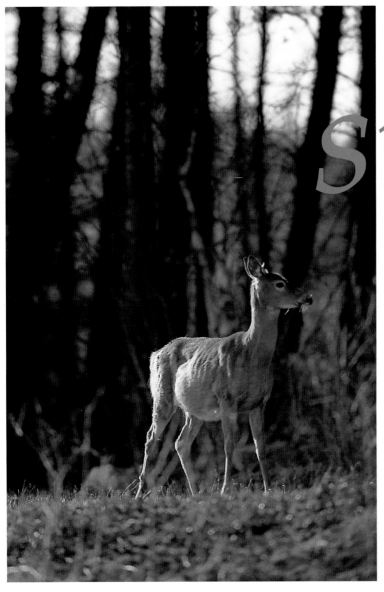

survival

One frosty February morning, I and my dog were walking through a semi-remote area of the woods. The air was crisp; I could see my breath turn into small ice crystals, then fall to the ground. The snow and branches made a muffled crunching and cracking under my feet. Except for my footsteps, there was absolute silence. I stopped momentarily. . . the only sound was my heartbeat. I walked on a little further and discovered something I will never forget.

It's always fascinating to watch wild animals with their young. Their instincts for protecting them is their primary concern. While returning on various occasions I saw this clutch decrease in size, I'm sure as a result of the varied predators that rely on them as a food source. . . and so the laws of survival apply.

Fortunes can change over the course of one season. After a bitter winter the effects are evident.

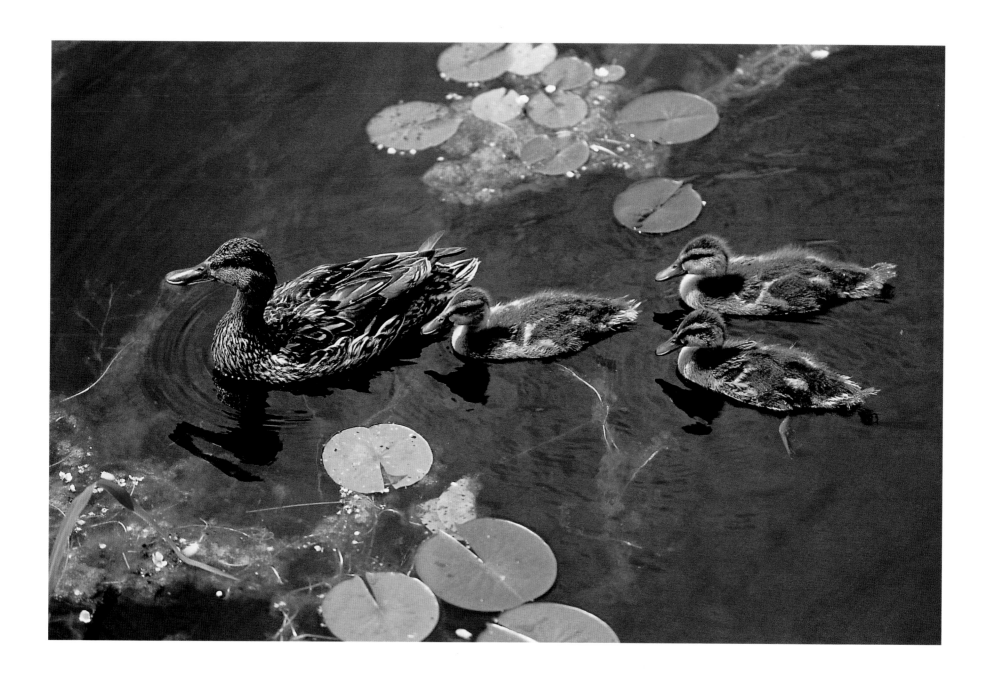

Getting skunked when hunting is just fine with me. Although most people wouldn't agree with me on that one, I really only go hunting for the experience. I now do more hunting with my camera than with a firearm, but do enjoy both. When I return from a hunt I certainly feel rejuvenated, and a much stronger connection to the natural world. This picture really makes me feel that connection because to me it is the journey that is the reward.

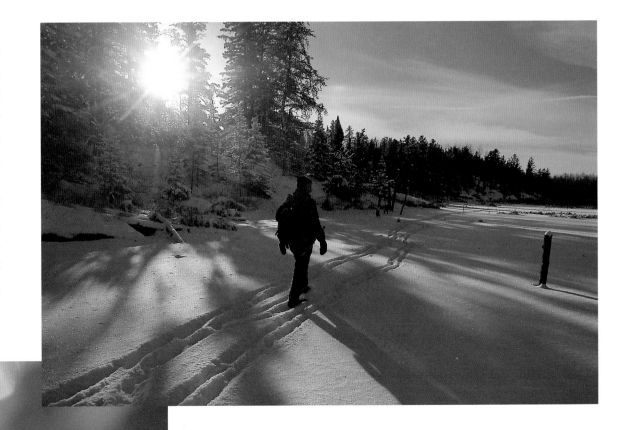

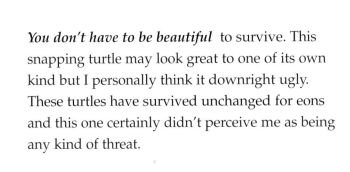

You don't have to be beautiful to survive. This snapping turtle may look great to one of its own kind but I personally think it downright ugly. These turtles have survived unchanged for eons and this one certainly didn't perceive me as being any kind of threat.

There in the snow just off the trail was a trap, empty except for the red fox's paw. I'll never forget this sad sight. It is not that I place any blame on the trapper; he is feeding his family. My thoughts were with the three-legged fox out there somewhere trying to survive. I would like to believe (against my better judgment) that it did survive this ordeal and go on to live a long and otherwise normal life.

One of nature's laws is survival regardless of cost. Our Northern Ontario wildlife population must survive through a myriad of potential hazards. As well as predators, extreme weather conditions, and a sometimes lack of food, there are forest fires which can rage out of control, consuming thousands of hectares of forest, destroying habitat and even the animals themselves.

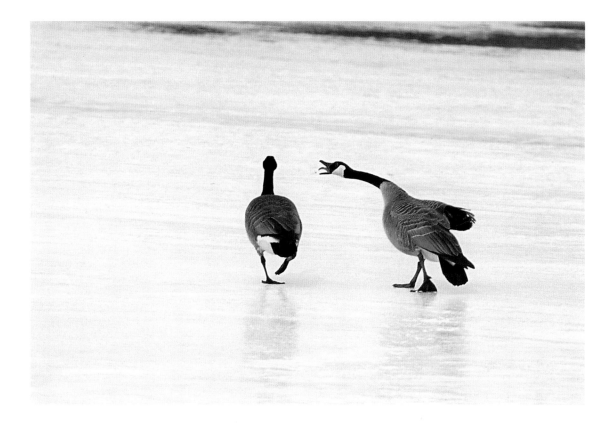

A domestic quarrel in any species has a certain look about it. When I saw this goose giving its partner the gears it could have been any old couple. It certainly isn't just human nature to disagree with the ones we love.

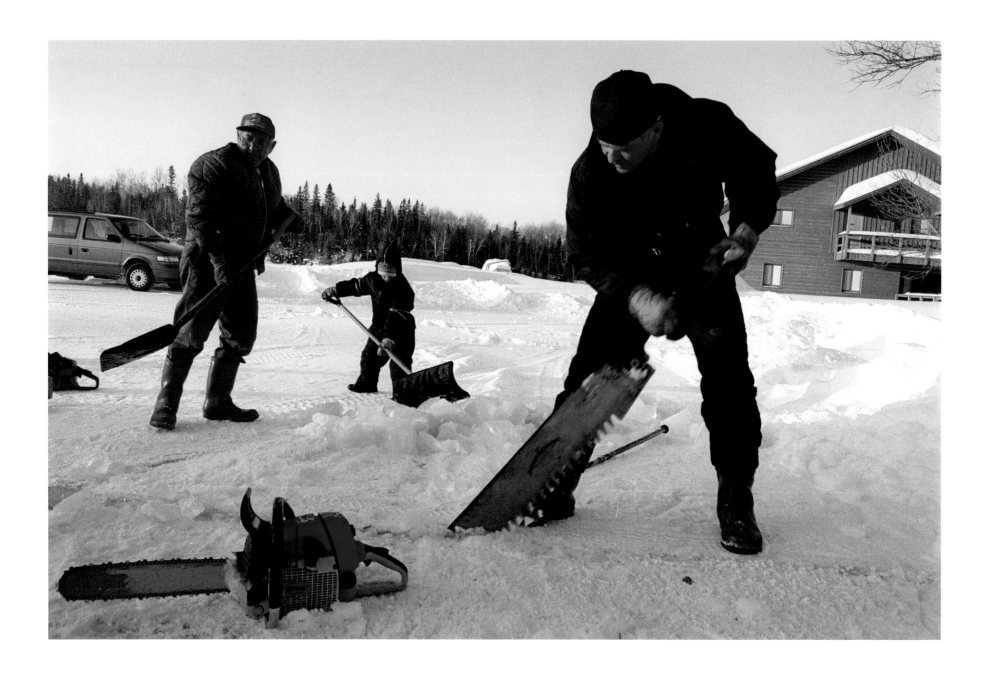

With some very physical labour and a well choreographed routine, the process of putting up ice for the summer repeats itself, more because of tradition than necessity. The Boucha family continues this tradition. Charles Boucha and grandson Ethan (L) sons Dan and Bob (R) and son Leonard (below).

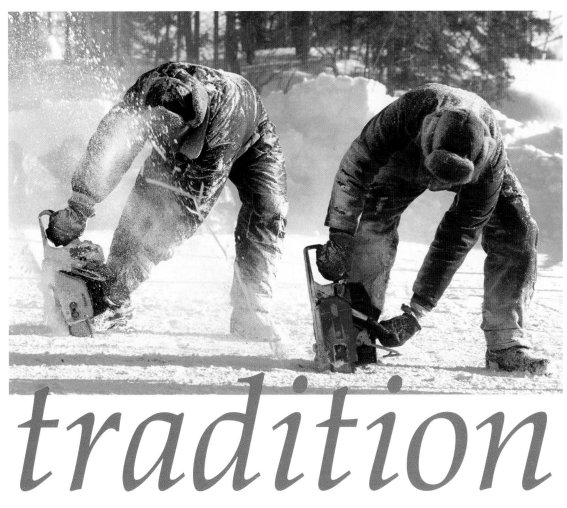

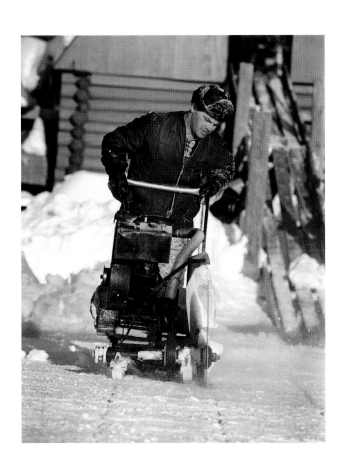

tradition

The Boucha family is one of a small number of families who continue the decades-old tradition of putting up ice for the summer. The process involves cutting blocks of ice from the surface of the frozen lake, then hauling it up to and storing it in an "ice-house" for the summer months. Although horses used for hauling the blocks have been replaced by trucks or snowmachines and handsaws

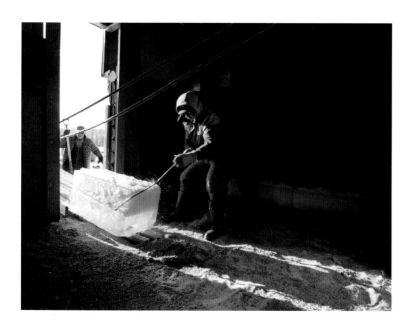

replaced by chainsaws, this most intriguing tradition continues from generation to generation. Charles Boucha said it was "the best ice for a glass of whiskey". When asked why they choose to do this today when modern refrigeration is available; some have said the nostalgia of keeping a tradition alive is what inspires them, others say the camaraderie of friends and family is what is important. The ice-house air, cooled by these gleaming blue blocks of ice, must be very alluring on a blistering hot summer day.

Grabbing 250 lbs. of ice as it comes sliding at you (above) is a test of timing, strength and experience. Doing it right will place the block right where it is meant to go, doing it wrong will mean a lot of extra work. When the work is nearly completed (right) a test of agility comes in the form of a dash across the floating obstacle course.

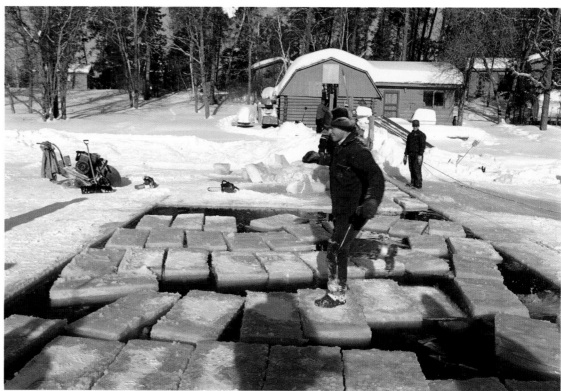

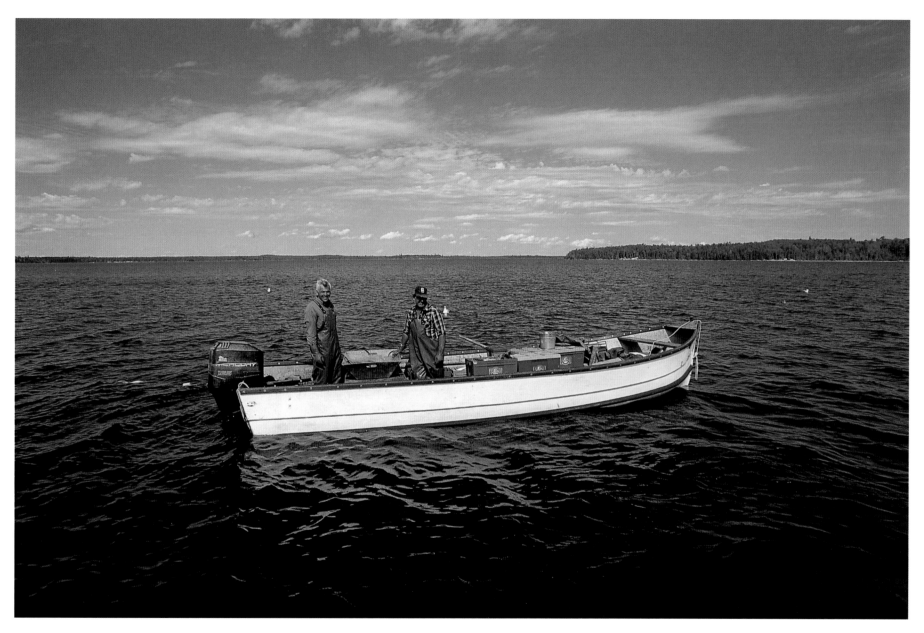

Charles Boucha (above left) 1939-1997

Looking straight down or straight up gives a different look to the everyday. The stacks of pulpwood (left) lined up so neatly awaiting their transformation into paper at a mill, create a strong design that leaves people wondering at first what it is they are looking at. The view of these trees (below) with the late day light and upward perspective creates a dizzying view.

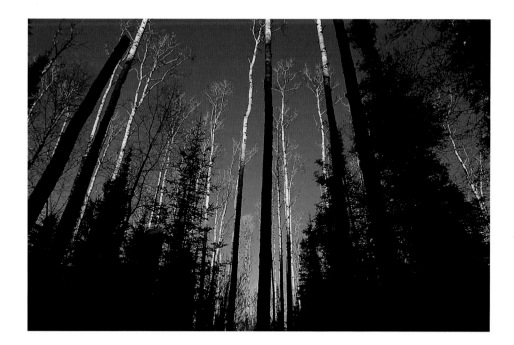

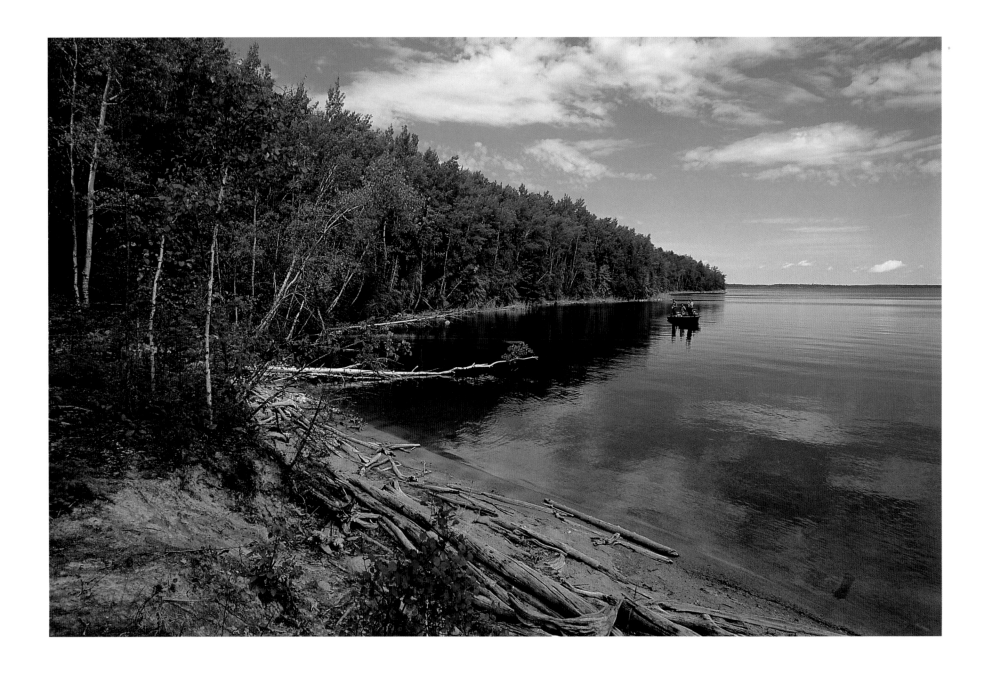

You could fish forever and never troll the same stretch of shoreline. While there are countless miles of beach and rocky shore the trick to finding the fish in the maze is usually to go with an experienced guide. The advent of fish locators and the myriad of fishing accessories do make the task easier for those unfamiliar with the waters.

adventure

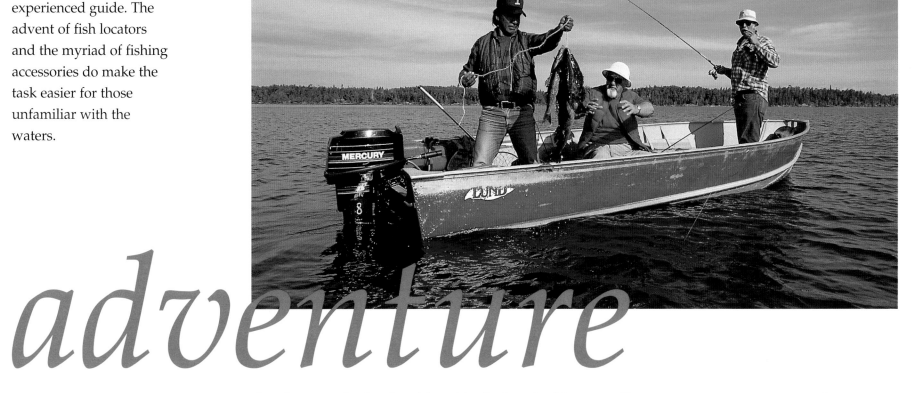

Lunch on a string is what this guide displays for his guests. For years some guests return to the same camp time and again because of the fishing and the great friendships that evolve between themselves and their favorite guide. A relationship like that is developed through the sharing of a common interest and a respect for years of dedication to honing the fine points of technique.

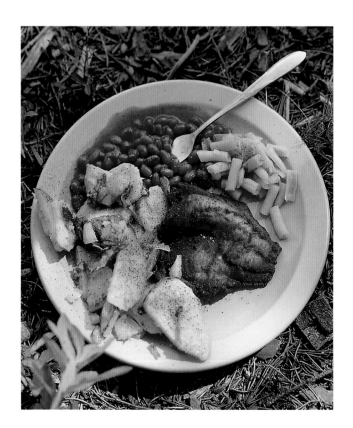

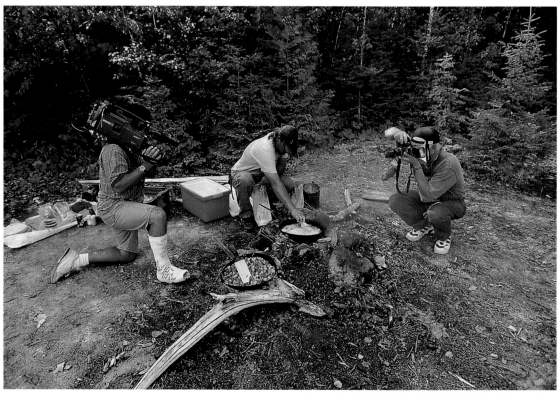

Photogenic food is not the only result of a good shore lunch, it tastes great too. There were many opportunities for retakes of this shot, I had three helpings.

The main attraction of any fishing trip is the shore lunch. The only real difference from one shore lunch to another is the coating on the fish, and there are as many secret blends as there are fishermen. While these two photographers try to capture the essence of the shore lunch, I felt the image of their interest said everything about the popularity of this outdoor experience.

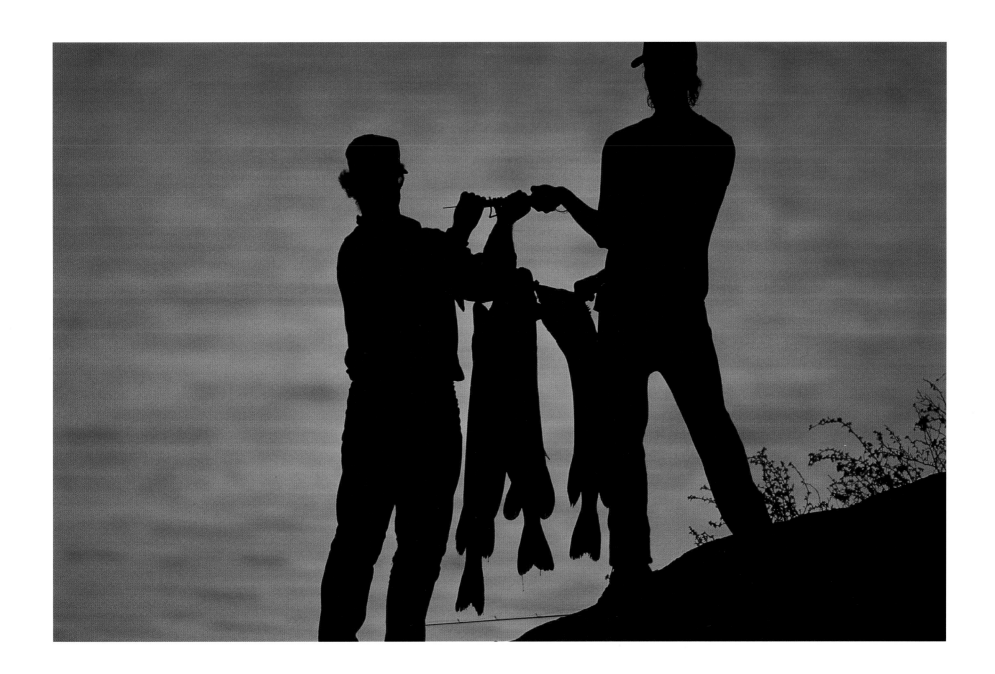

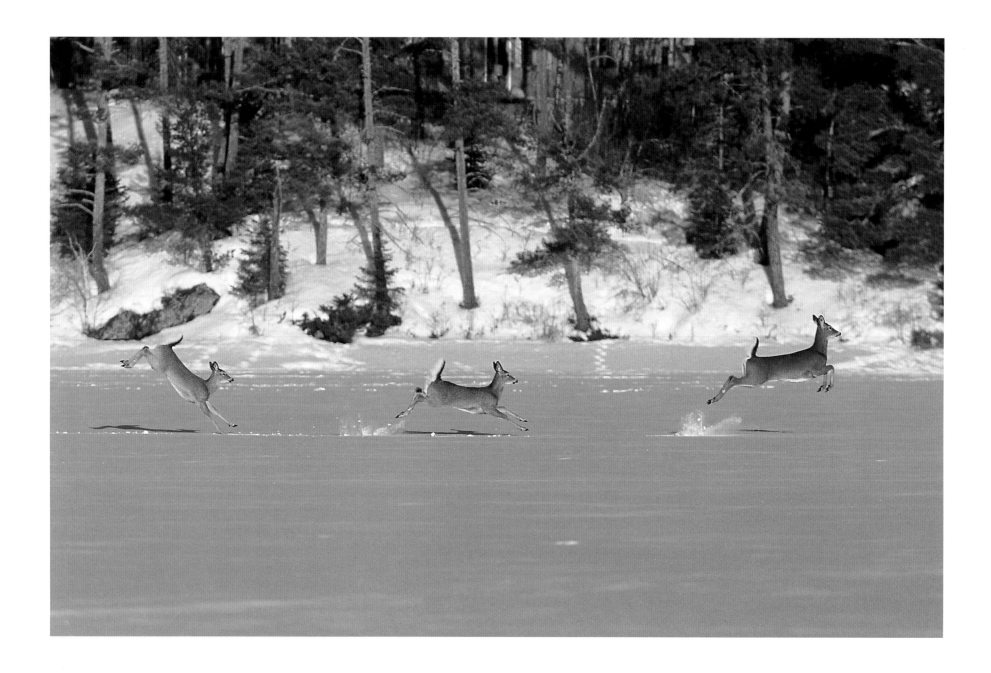

Poetry in motion is what really makes this image work. These three deer were very approachable as I slowly tried to get close to them, but when their safe space had been violated they left in a very beautiful hurry. Of the 20 or so shots I got off as they danced their way to a new safe zone, this one had that great balance that only shows itself at 1/500th of a second.

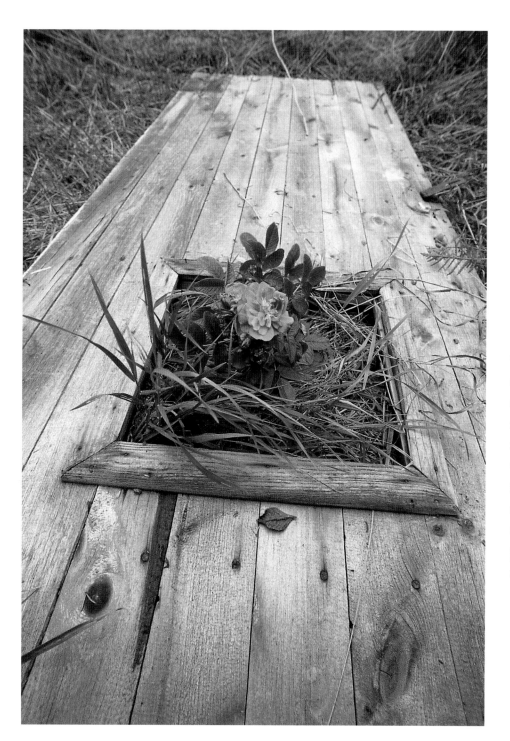

This framed rose was the result of decay. The door of an old building had fallen loose of its frame and caught the edge of a wild rose bush. This act of age and decay created a rather poignant image of new and old.

Navigating your home on the lakes of Northern Ontario is the truly unique thing about houseboating. A change of scenery is possible whenever you wish. Pulling a houseboat right into the marshes and bays where the birds carry out their daily routines has certainly given me many hours of comfortable picture taking, with the fridge and washroom right at hand. . . Nobody said it all has to be hard work.

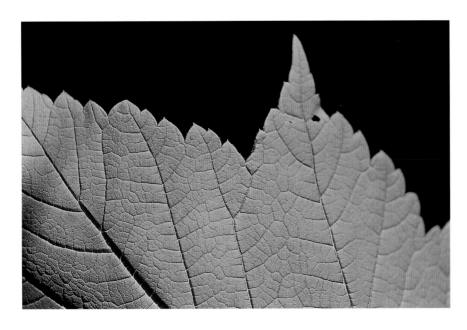

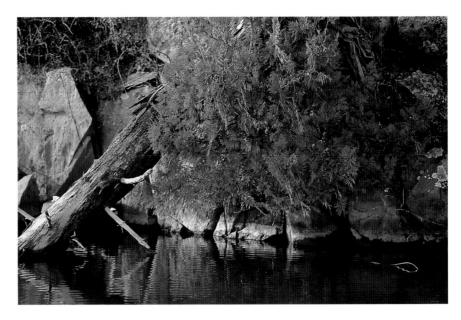

Patterns of life show up in many of nature's details, the veins of this backlit leaf show the pattern of growth and life.

Millions of miles of ever changing shoreline can produce some images ranging from the serene to the very dramatic. While out in a boat I am constantly looking and stopping along my way to shoot pictures, which for everyone else in the boat with me can get a little irritating, fortunately my family is very understanding and don't even question the about turns that happen completely without notice.

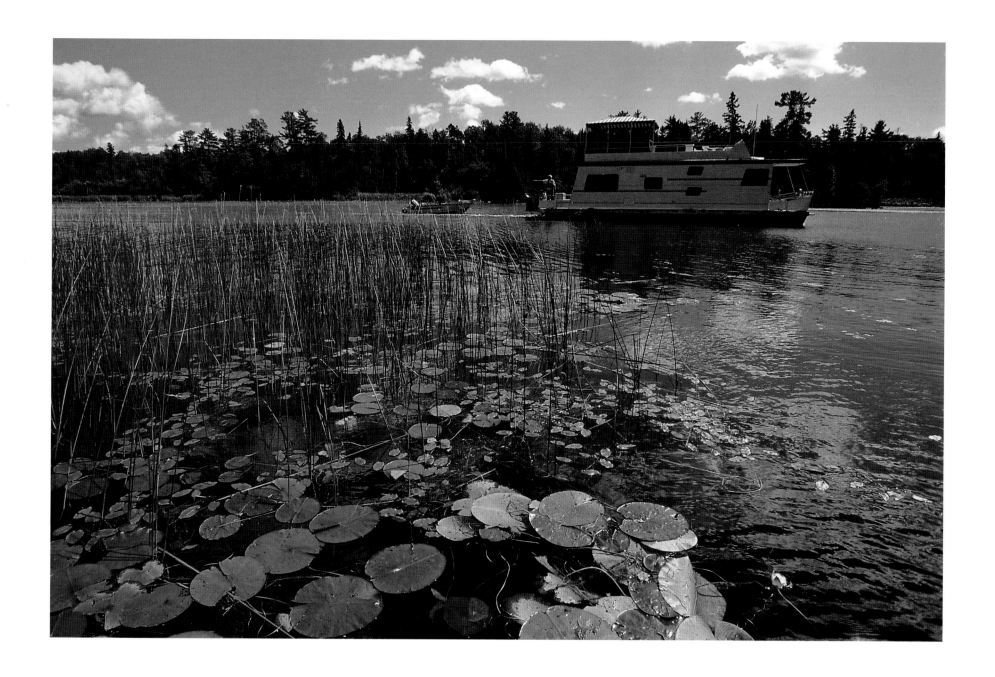

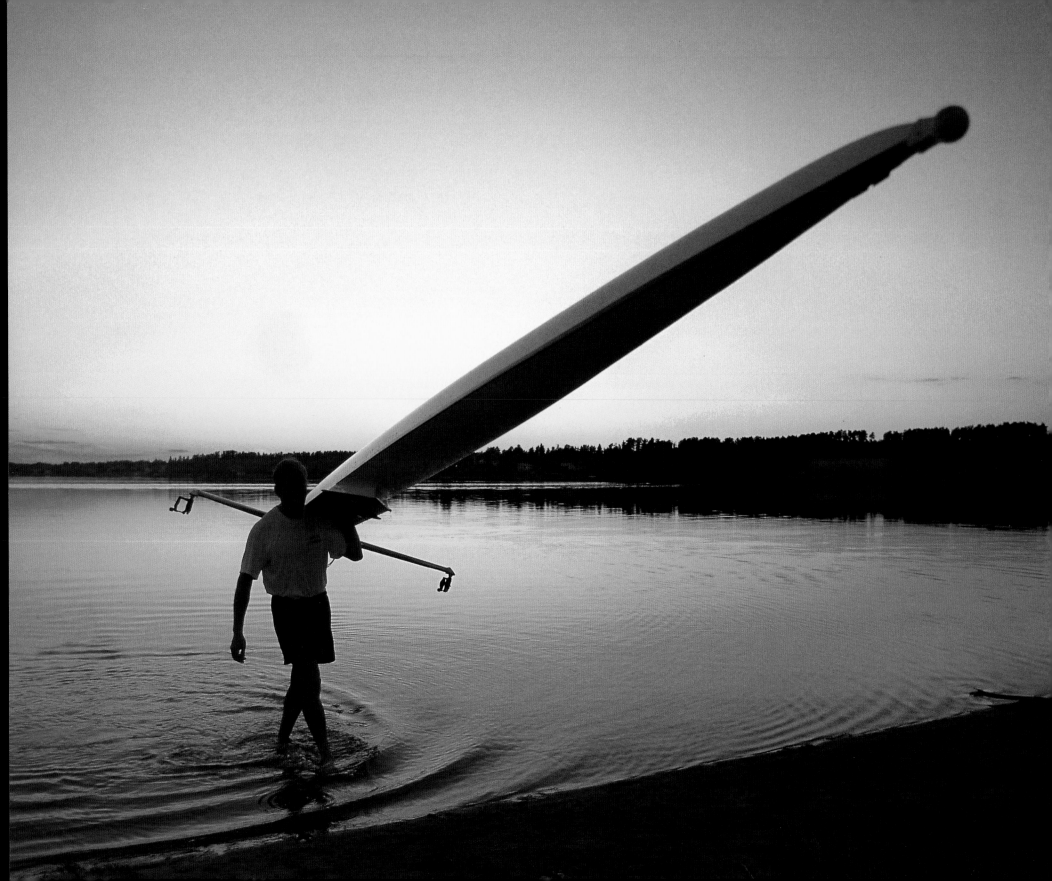

An evening workout ends with this routine of putting away the scull for the night. Some exceptional rowers have emerged from the waters of Northern Ontario.

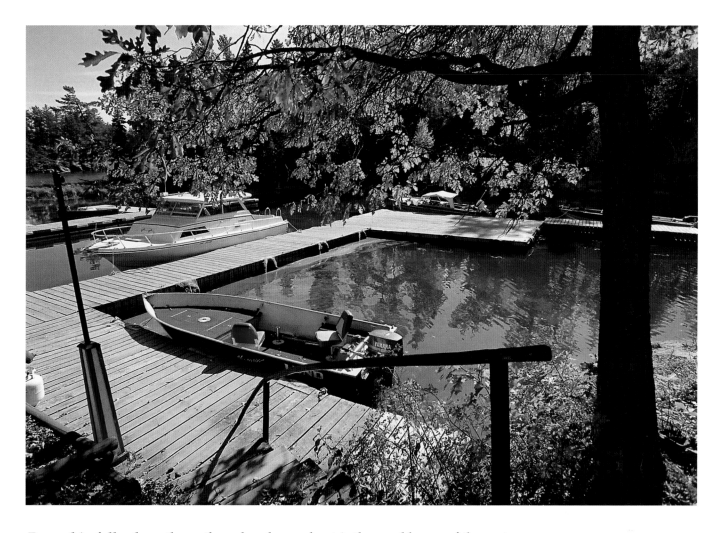

Framed in fall colour, the outboard and open boat is the workhorse of the waters. While the large cruiser in the background is excellent point A to point B transportation, it can't navigate the shallows like the smaller more manageable fishing boat in the foreground. Not everyone can afford it but having both is certainly the way to go.

Personal details vary from camp to camp. A splash of colour amongst the otherwise monotone surroundings in this setting I felt truly reflected the character of the owner, a wonderful woman who feels a strong attachment to her place in the north.

The three little chairs with the three people in them distracted me from the buildings I was there to take pictures of. I guess I am always more interested in the patterns of life than the patterns of the static. When I saw this scene I only had to wait moments for the girl on the right to reach over to her mother and make the connection that made the scene more personal. Then I went back to the static (but paying) patterns of the buildings.

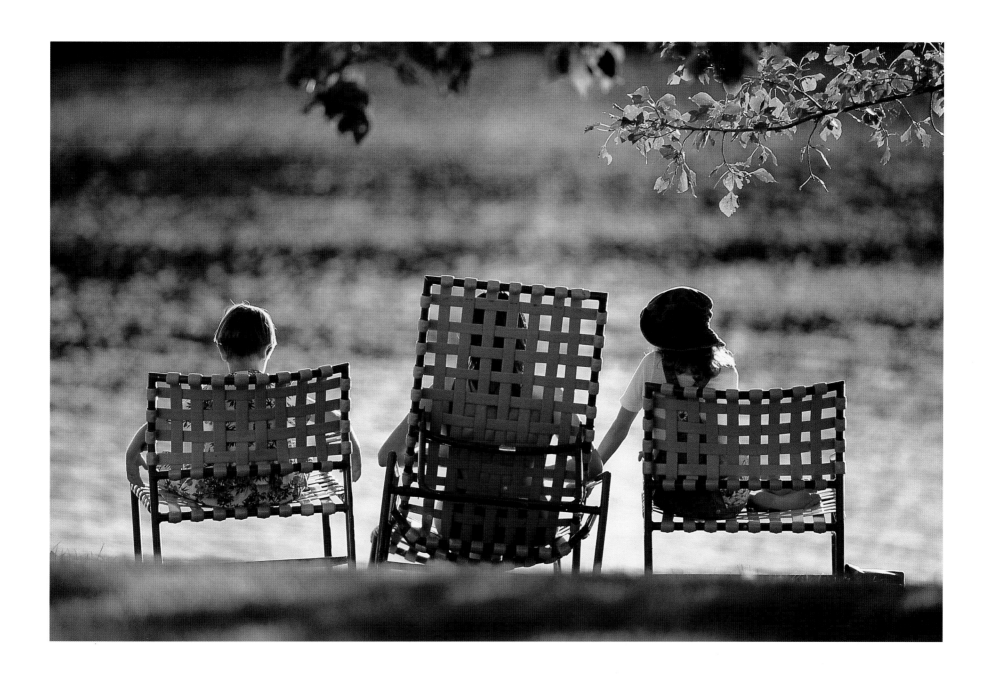

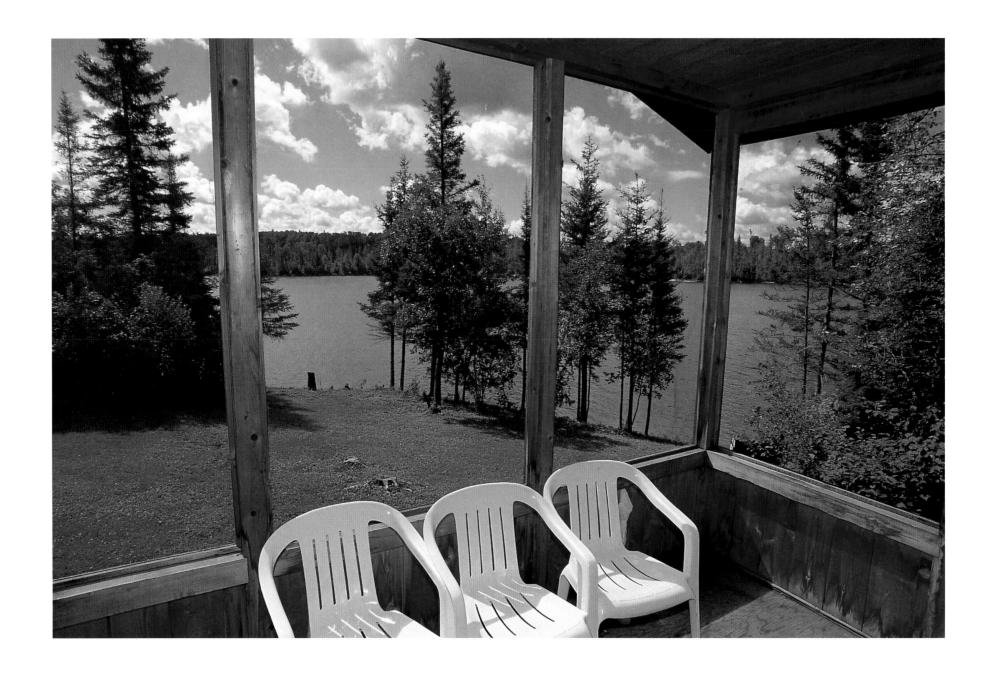

A porch view is a big component of owning any waterfront property. Camps from opulent to modest generally have some form of deck or screened-in porch overlooking the enticing blue waters of Northern Ontario.

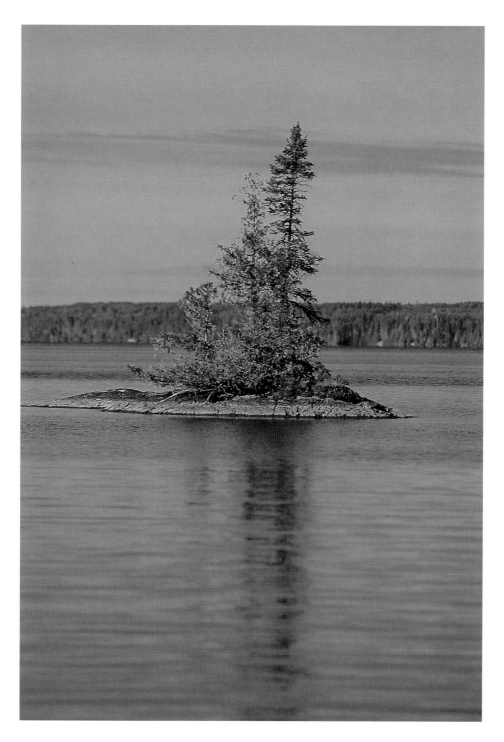

This lone sentinel casting a reflection on the calm waters, can at night act as a navigational aid by standing out from the distant background shoreline. To traverse the waters of northern lakes after dark, natural markers such as this and years of experience are prerequisite to venturing out in the night.

Like a skipping stone, this cub bounces in for a landing delivering minnows to one of his tourist camp customers. These planes are perfect for the little bodies of water that dot the north of Ontario because they can land and take-off in a very short distance. They are also extremely good on gas and cheap to maintain. It almost seems all you need to keep them in the air is a screwdriver and some duct tape.

wings

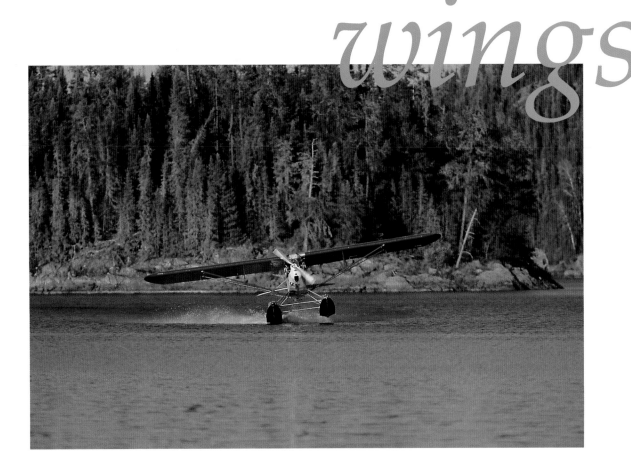

This exuberant dance is a reaction to my approaching too closely. Loons are birds that mate for life and in the spring can be seen with their young silently cruising the still waters of the north, teaching them the ways of survival. While shooting the pictures of this particular loon, I backed off after a short time because I felt I was getting a little too close for the parents to feel comfortable. Just as I backed away I noticed the dark silhouette of a muskie rising up to grab the baby loon. While I don't normally like to interfere with the ways of nature I instinctively banged the side of the boat and scared the predator off. While I sat on a dock near there at sunset and wondered if it was the right thing to do, I was convinced by the calls of the parents that it was OK . . . this one time.

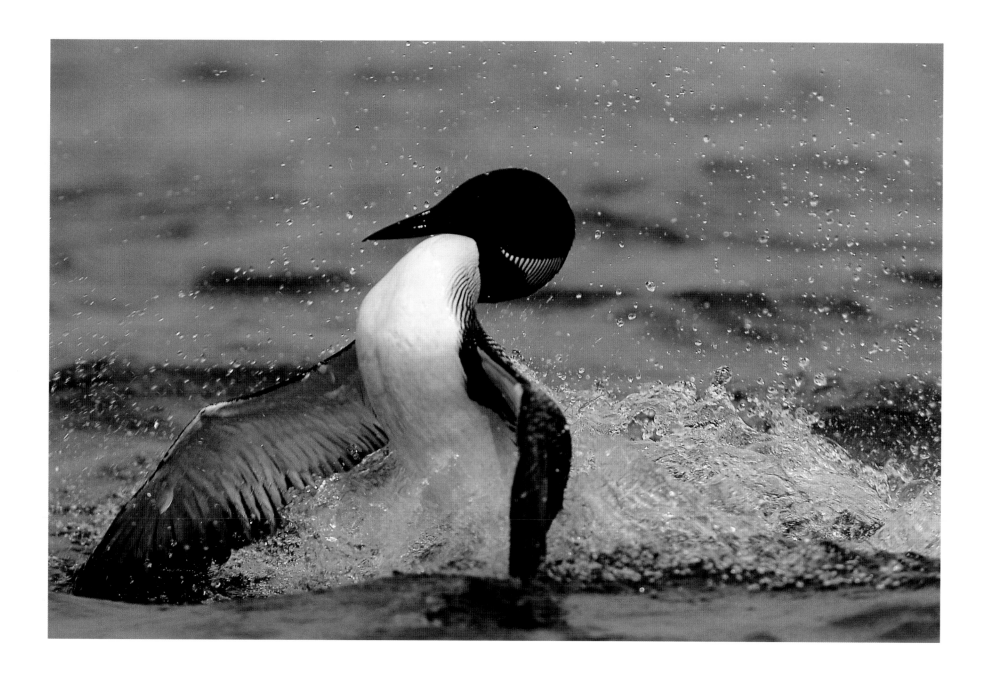

This golden arch becomes an abstract combination of urban function and form when it is reflected in the water at sunset.

sunset

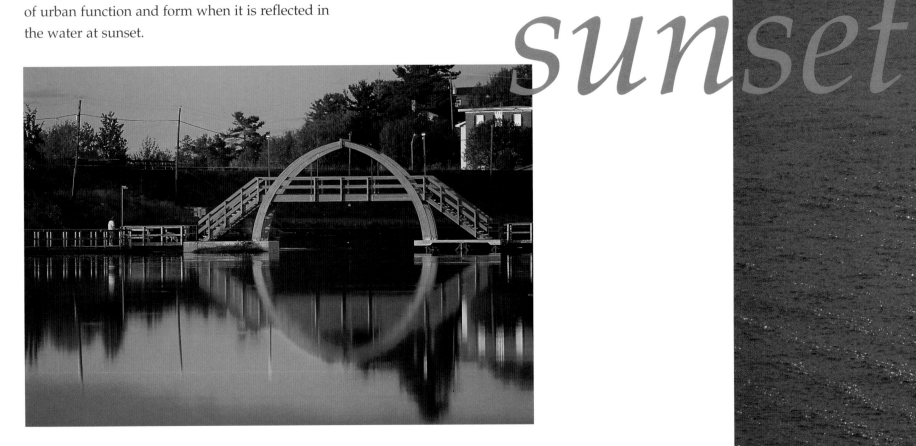

Parting the golden waters of a northern sunset, this boat left in its wake another stunning pattern of liquid sunset. While sitting high on a lofty outlook watching the sun set and the boats come and go, I was treated to an endless display of crimson art that was in constant motion.

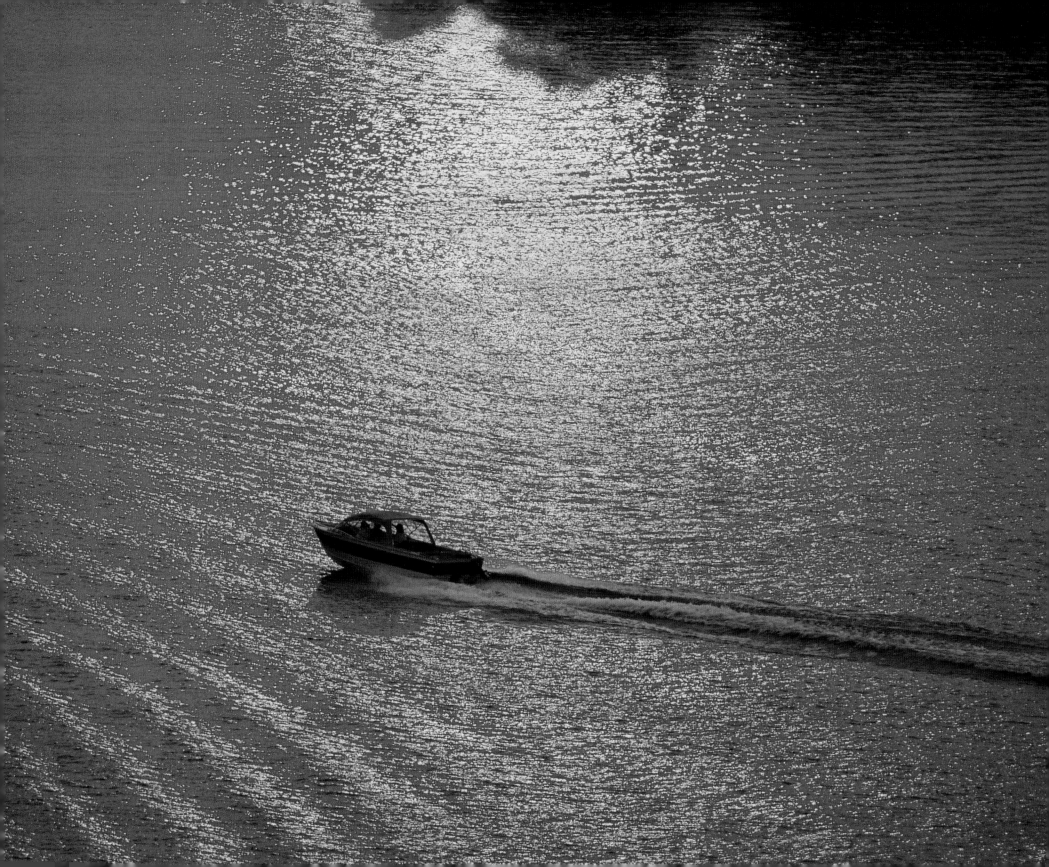

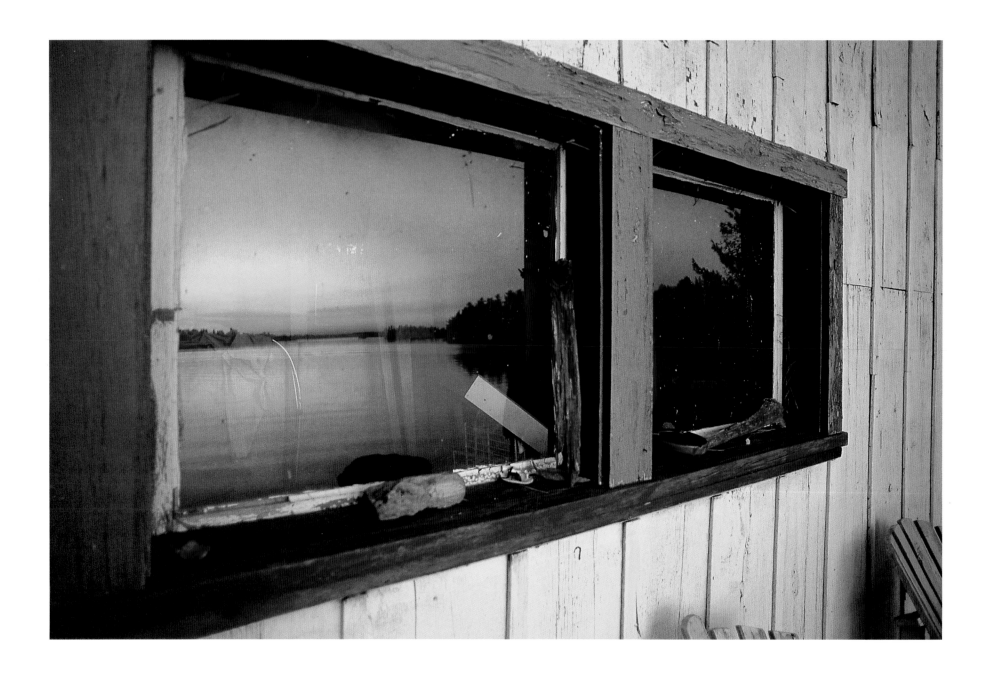

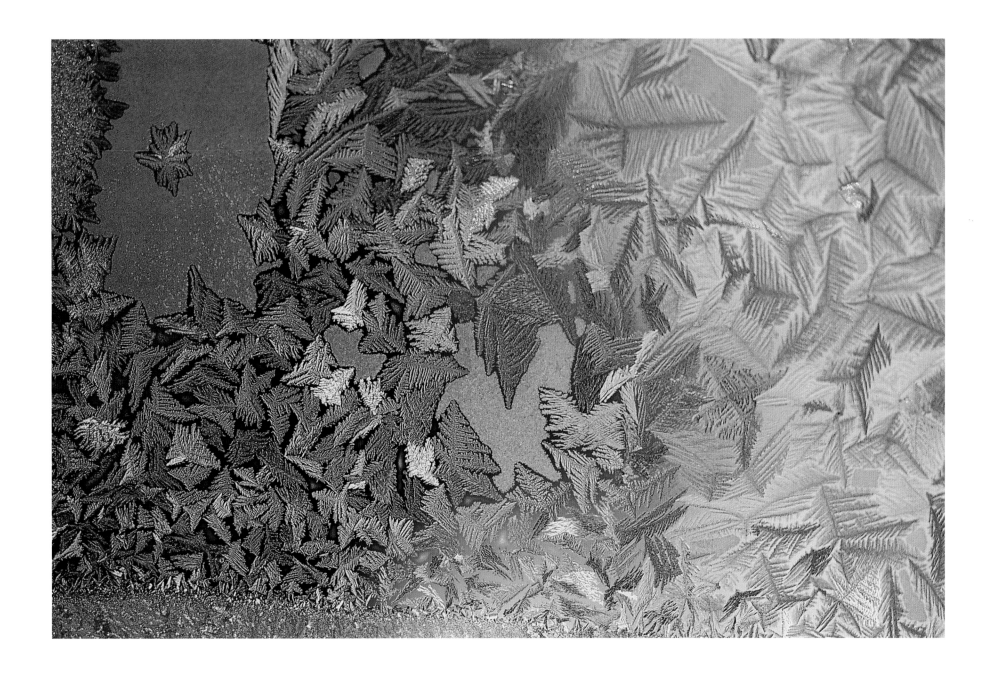

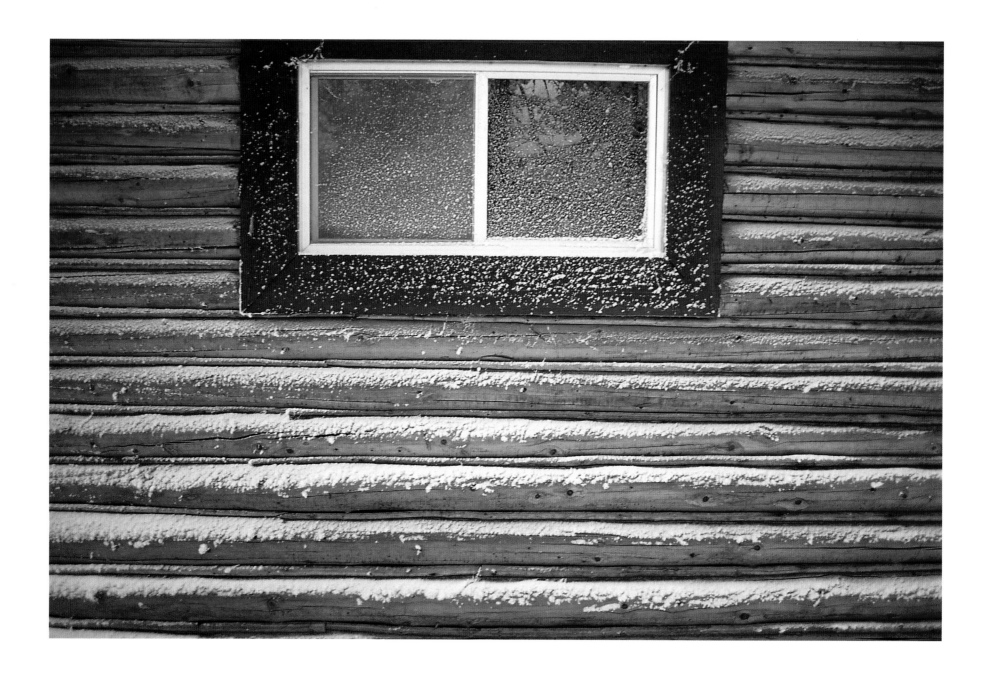

After a dusting of snow,
I was attracted to the
pattern of logs on this
old trappers shack.

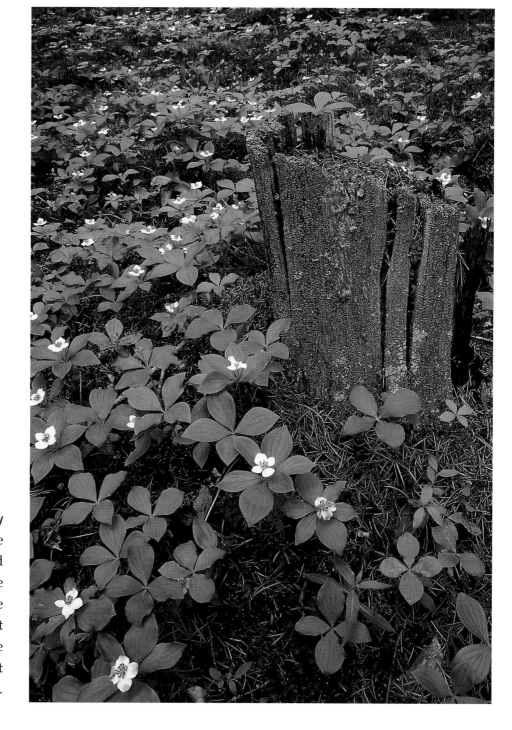

A carpet of bunchberry
(*cornus canadensis*) covers the
forest floor. The decaying old
stump of a long dead tree
provides nutrients for the
plants surrounding it. I felt it
was a telling image of the
ongoing process of forest
regeneration.

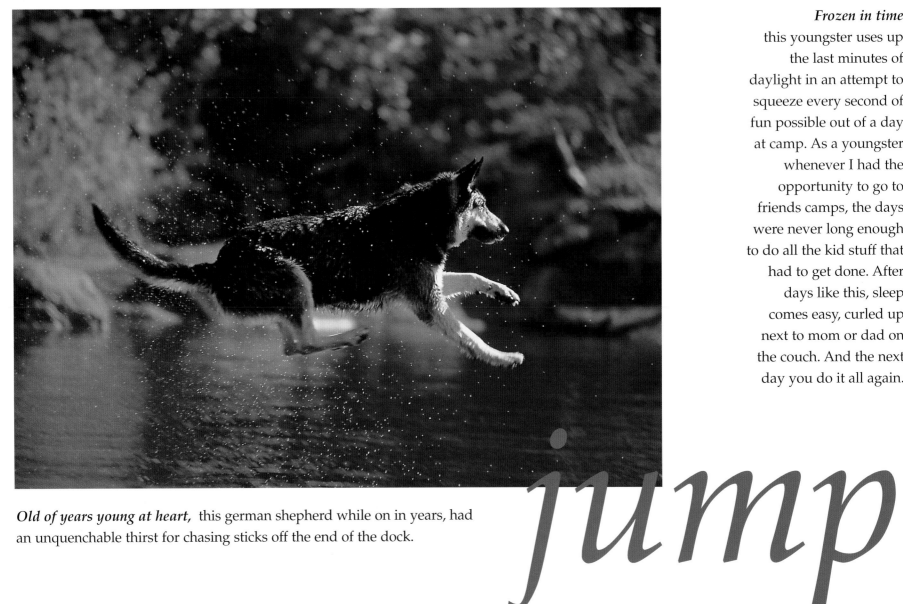

Old of years young at heart, this german shepherd while on in years, had an unquenchable thirst for chasing sticks off the end of the dock.

jump

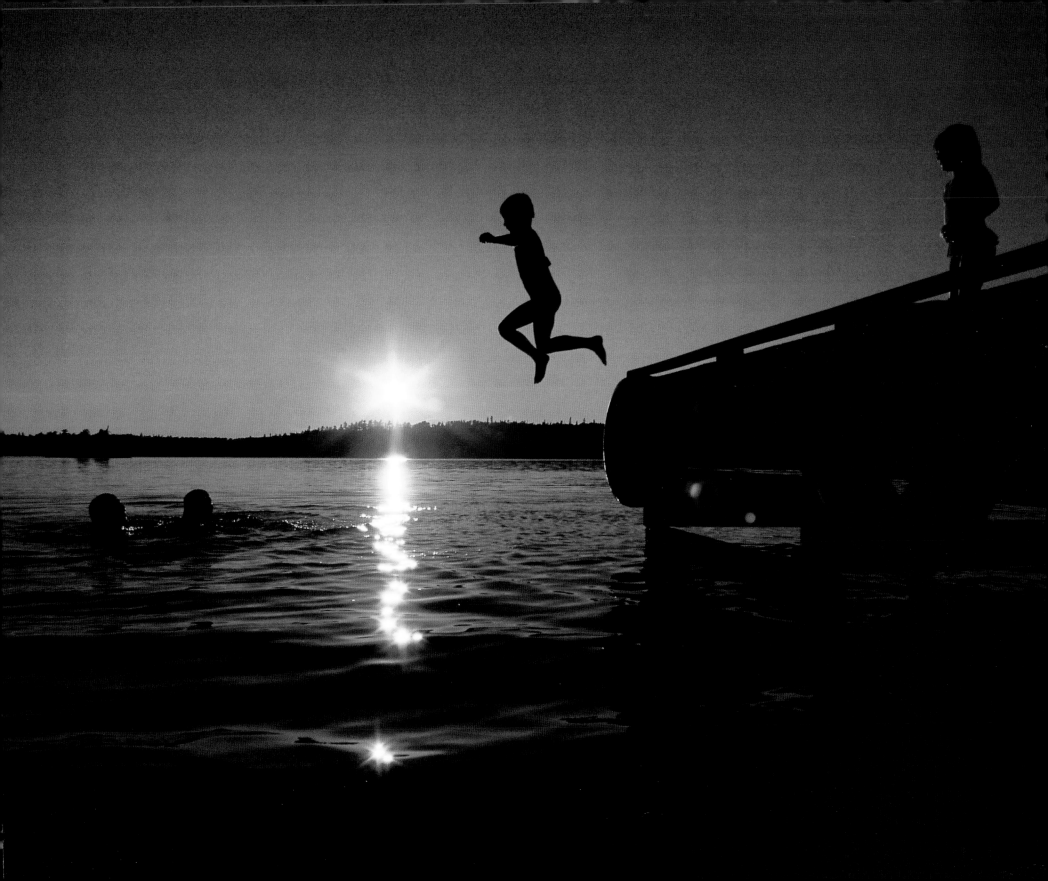

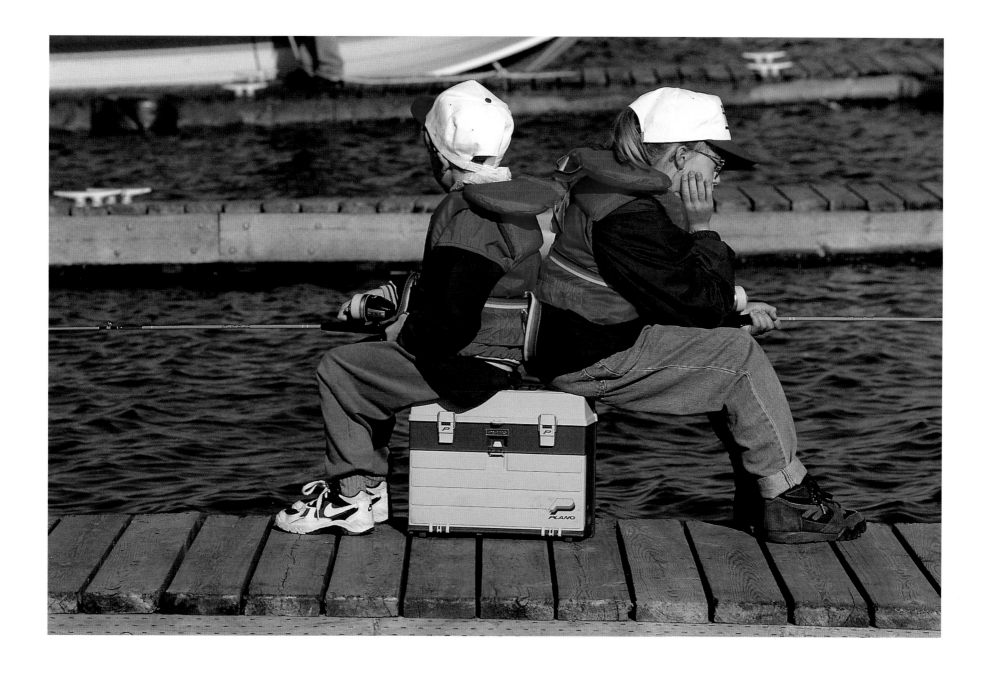

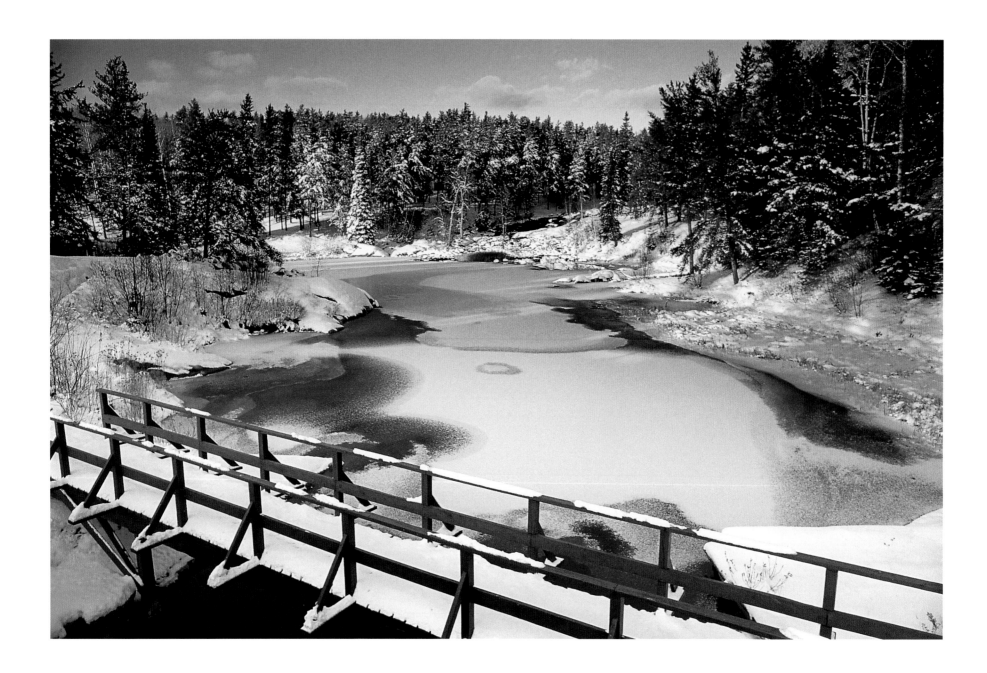

Scenes of quiet solitude like this can be found right at the roads edge. While it is the warm evening light, contrasting with the cold blue tones in the shadowed area of ice that make this a good picture, I was really pleased that I merely had to step out of my car to capture this image during a cold winter twilight.

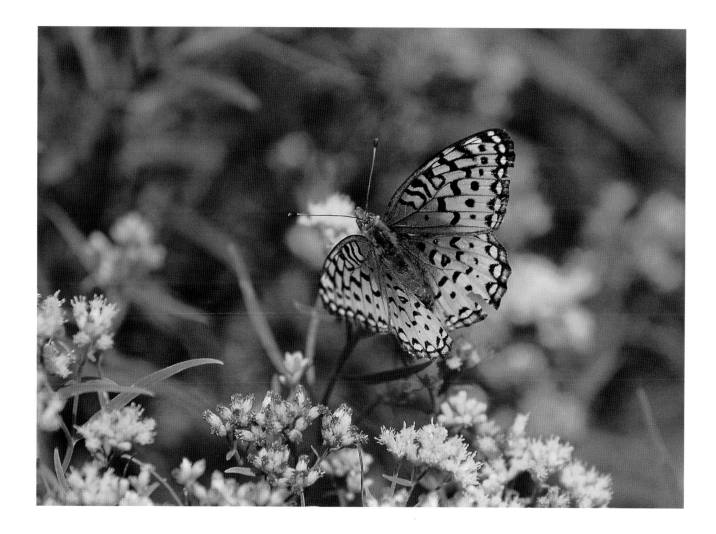

Using colour and pattern to both hide and show off, this butterfly danced among this similarly coloured foliage in its search for food thus making it hard to see by its enemies, but the dramatic patterns of its wings makes for an enticing display to attract a mate.

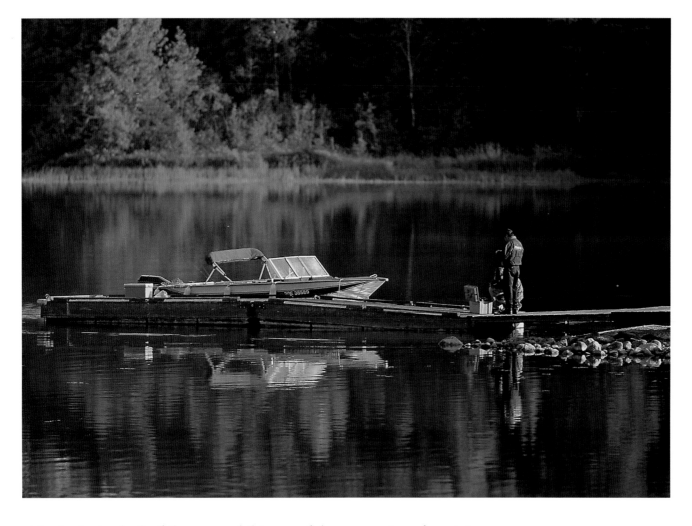

A last minute check of the gear and this peaceful scene can transform into
an explosion of action as someone hooks a lunker, making the trip worth
every cent for the many anglers that descend on the lakes of Northern
Ontario in pursuit of its abundant sport fish.

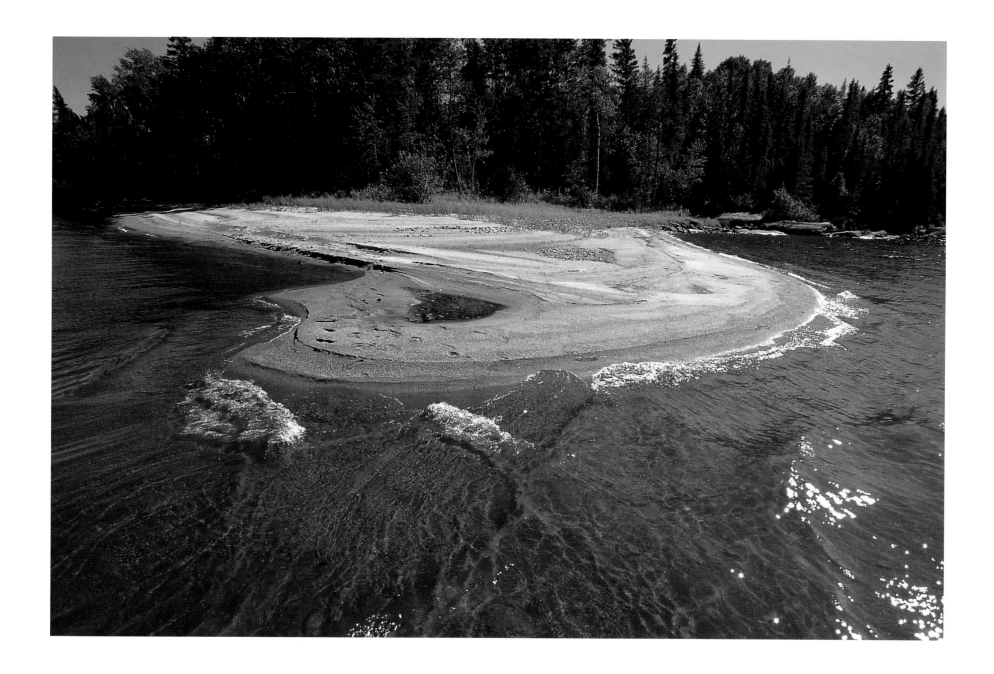

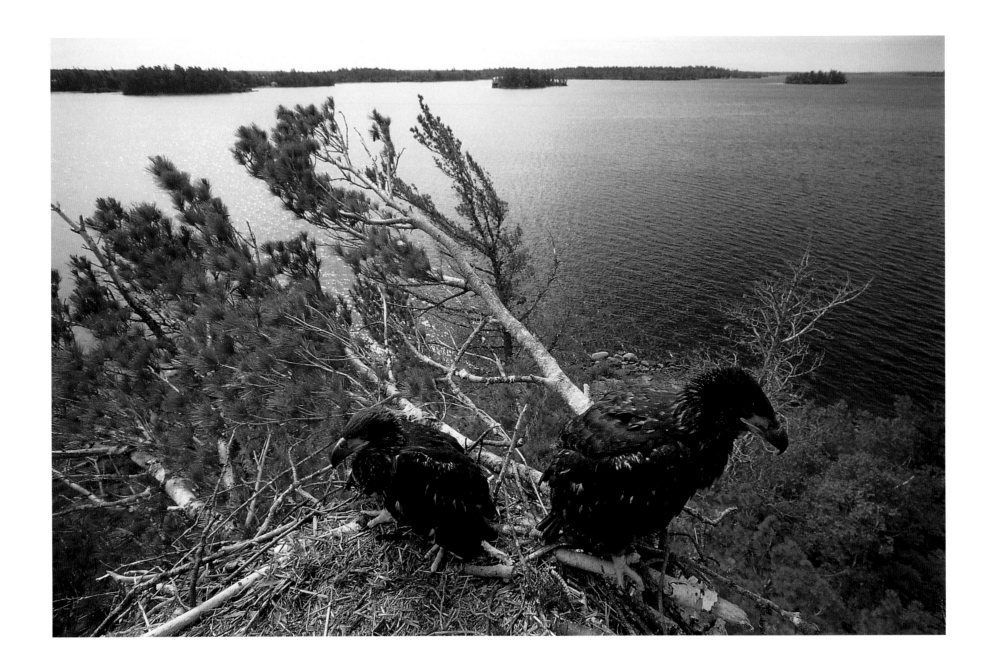

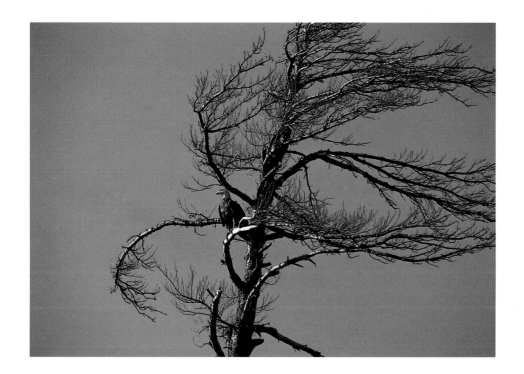

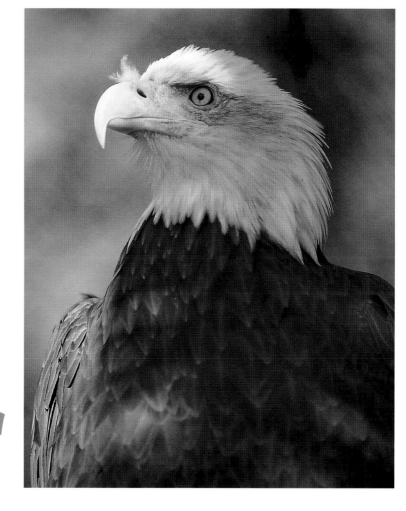

majestic

The personalities of these fierce-looking hunters differ greatly from one bird to the next. Some eagles are very nervous and yet others are quite adaptable; the boldest of which even build their nests in the middle of cottage developments. They are protective of their young, often watching the eaglets from a nearby tree to give them a sense of independence. There are more than 1000 active nests in this area alone. With this in mind, it is hard to fathom that they are on the list of endangered species. The cause of their frightening decline was due to one of the world's most destructive forces . . . man. In the past DDT caused the shells of their eggs to be so thin and brittle that very few eaglets hatched. Ontarians can be proud of the tremendous effort put forth in the past 40 years to sustain the species. The Bald Eagle "comeback story" is proof that if we take the time to respect our fellow inhabitants, we will all have a better earth.

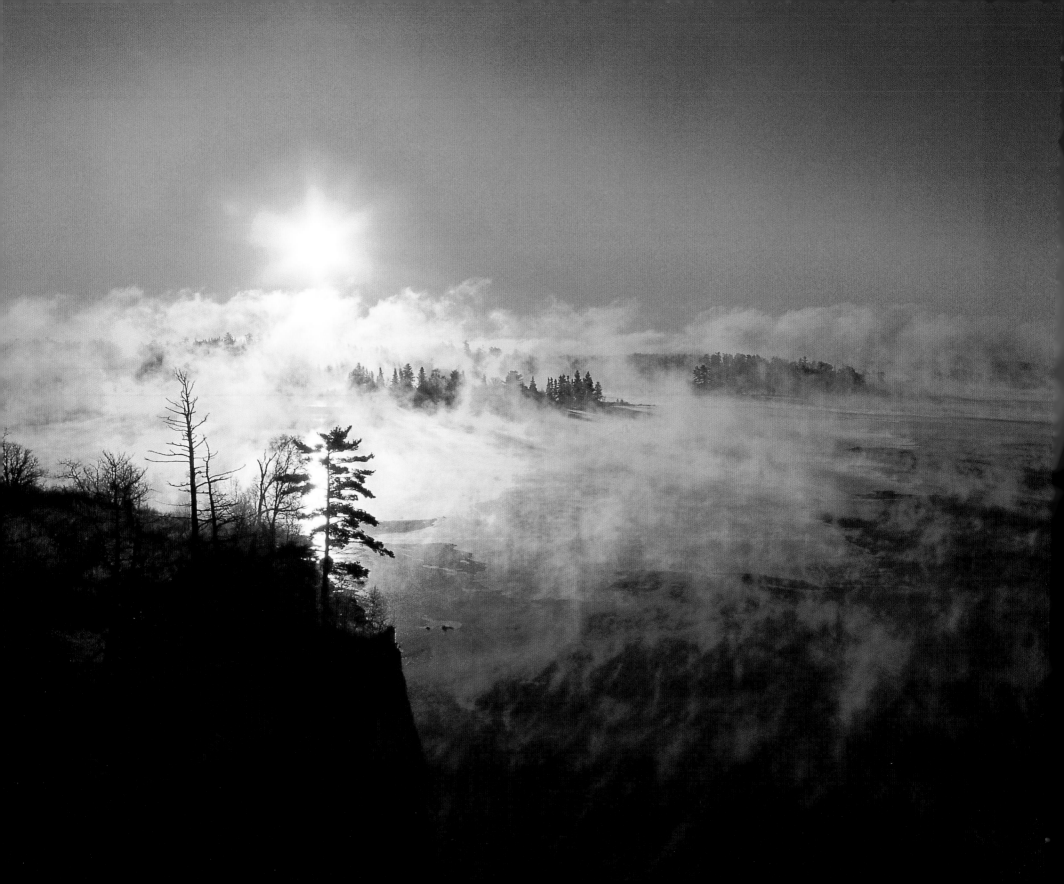

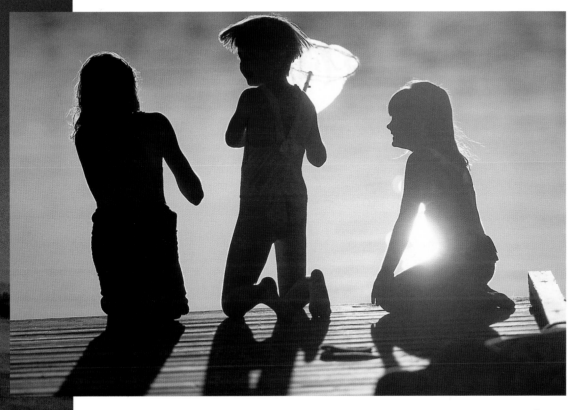

Long days of playing til sunset catching minnows and crayfish are what memories are made of. I found my own pleasure in watching these kids enjoy their time at the lake. Oh to be young again!

The change of seasons is portrayed here by the sunrise cutting through the mist created when the warm waters of summer begin to cool.

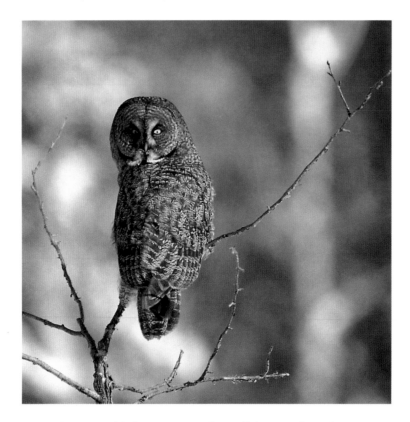

On a bitter cold day I received a call from a friend saying
that he had seen an owl in a tree an hours drive away.
When I arrived sure as heck there it was in the tree. Some
days are like that.

Out and about in a boat one morning shooting pictures of a flock of
pelicans I rounded the next point and saw this scene, I switched from a
telephoto lense to a wide angle to capture this image. When I awoke that
morning I had visions of wildlife on my mind, but was just as happy to
have this shot. Some days are like that!

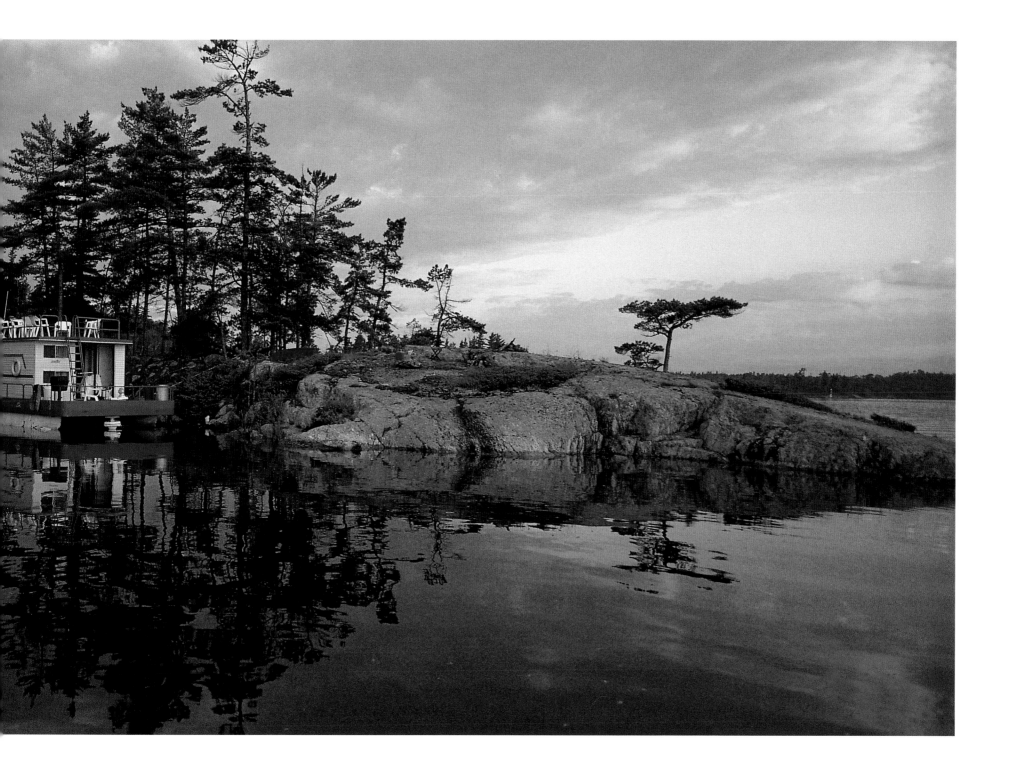

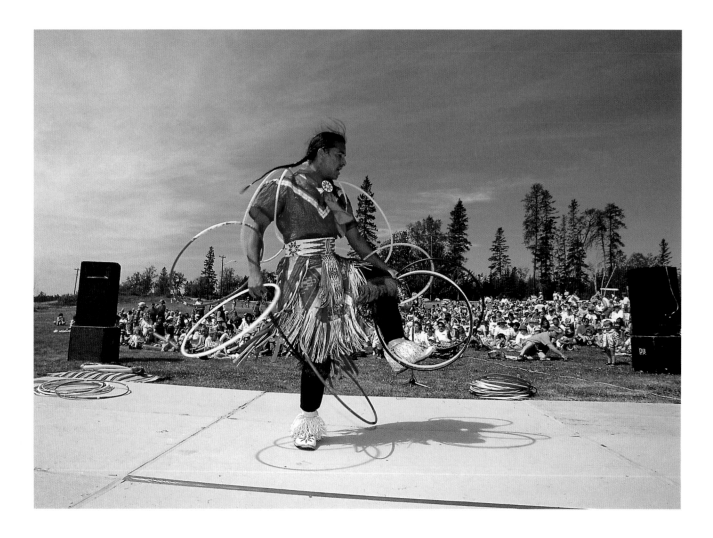

I have walked by this scene at least a hundred times on my way home from my office. Everything fell into place one evening when the colours of fall and the late day light made me stop and shoot this composition . . . I also had a camera with me this time.

Hoop dancing is a native tradition that is truly amazing to watch. When anyone is passionate about what they do, it shows. This dancer was extremely proud of his culture and it made it a challenge for me to really show off the eloquence and intricacies of this remarkable dance form.

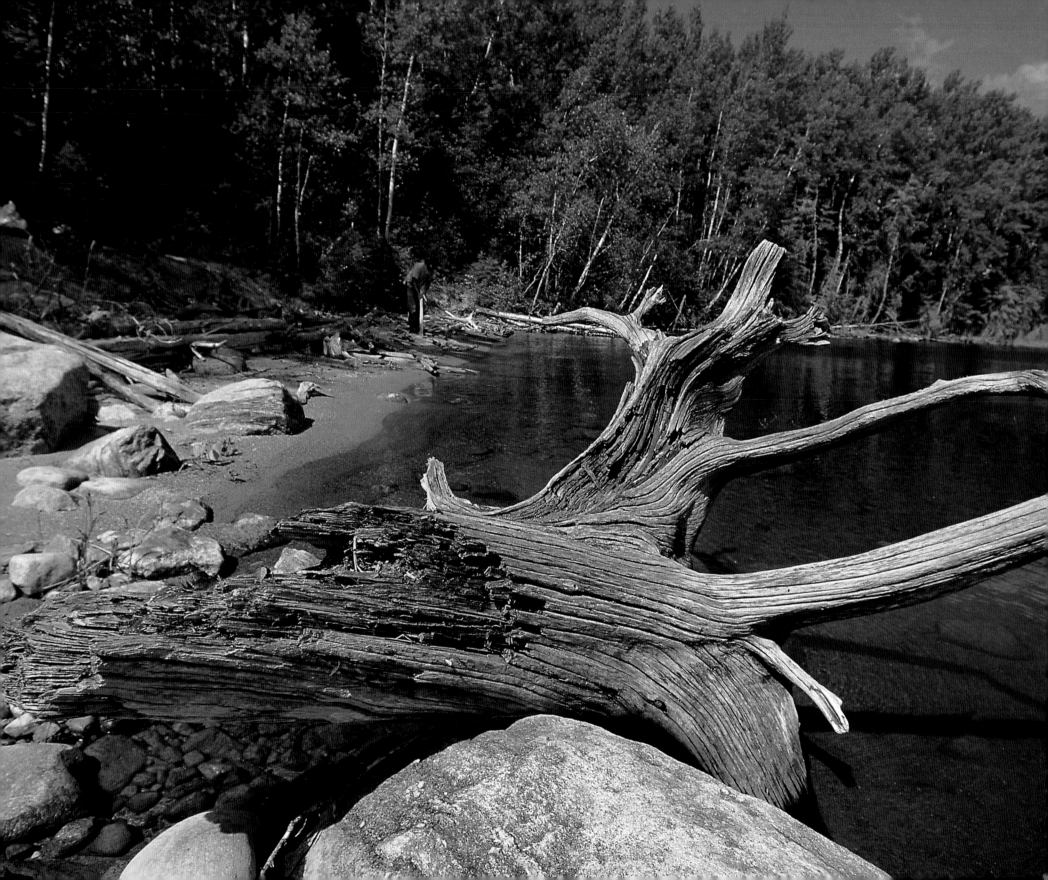

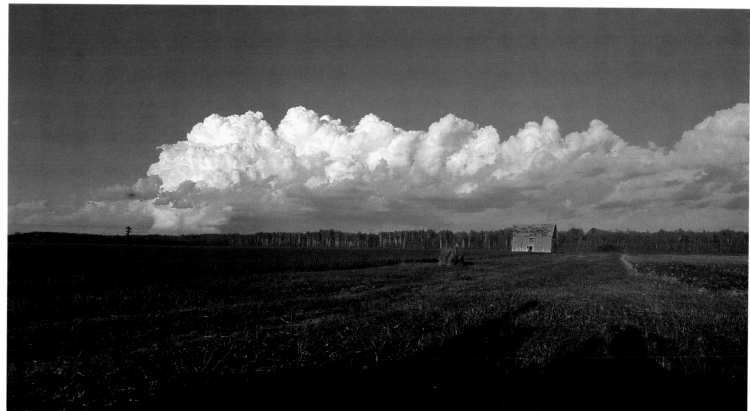

diverse

The green rolling hills, pools of electric blue water, and the grays and browns of the "Shield"; provide a wide palette for our eyes to focus and feast upon. With the seasons, this palette may soften or intensify as if a painter was mixing "just the right shade" for his masterpiece. A view of this land from above brings to mind an artist's rendering; with the green of the forest nestled against the blue water, and the soft curve of the shoreline.

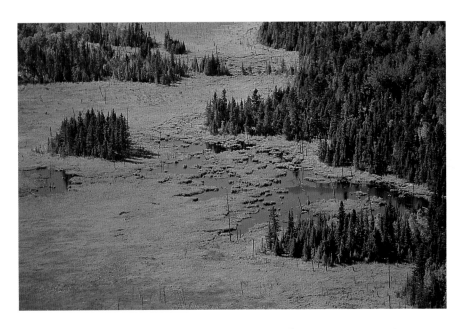

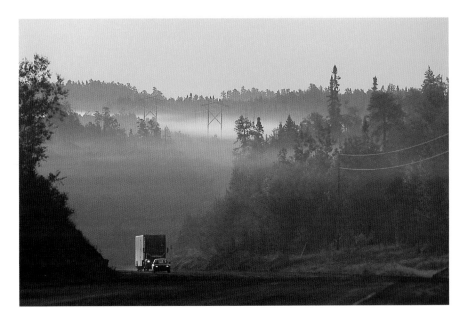

A variety of terrain defines the look of Northern Ontario and becomes very apparent when flying over the lakes, rivers and forests that stretch as far as the eye can see.

Cut through the Canadian Shield the roadways of the north are as scenic as they were difficult to carve out.

The geographic changes from one mile to another, from rocky heights to lowland marshes makes road building impossible in some areas. Some remote Northern Ontario communities and homes cannot take road travel for granted and are accessible in winter only by way of ice roads, in summer by boat or floatplane. It seems ironic that a remote forest can be consumed by fire when surrounded by the lake it drinks from.

The people of Northern Ontario are as diverse as the land. We are of many different ancestries, but of one nationality. The ways in which we earn a living, raise a family and have fun, are many. That is what makes life here so wonderful; we have so many choices on how to enrich our lives. Our blended culture is like a "coat of many colours" that we wear proudly.

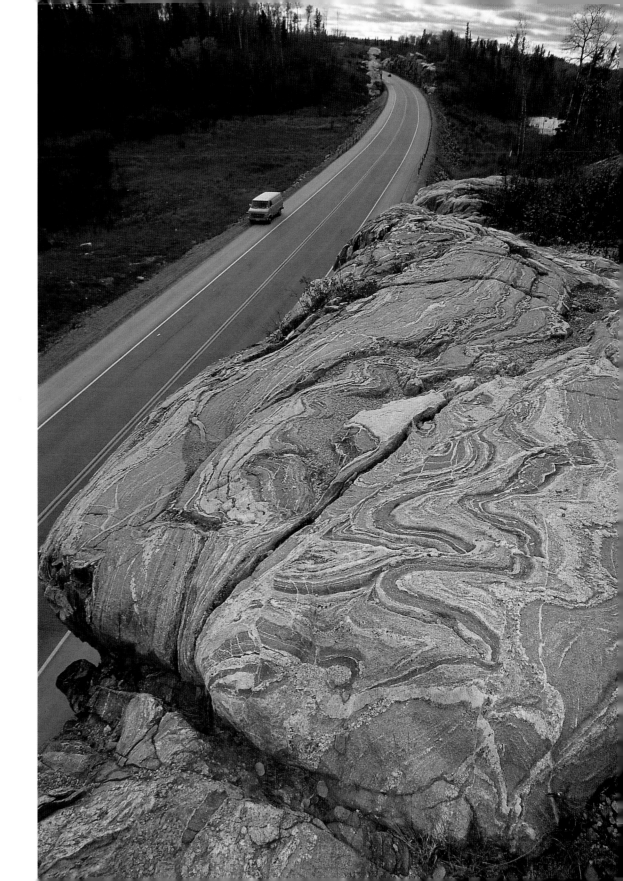

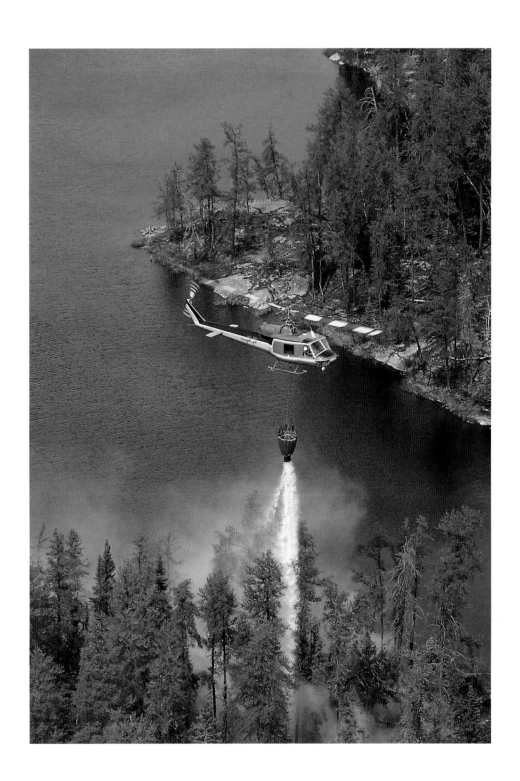

Skimming the treetops in its fight to extinguish a fire that threatens the forests of Northern Ontario, a helicopter drops its load of water plucked from the myriad of lakes that provide life to the ecosystem they work to protect.

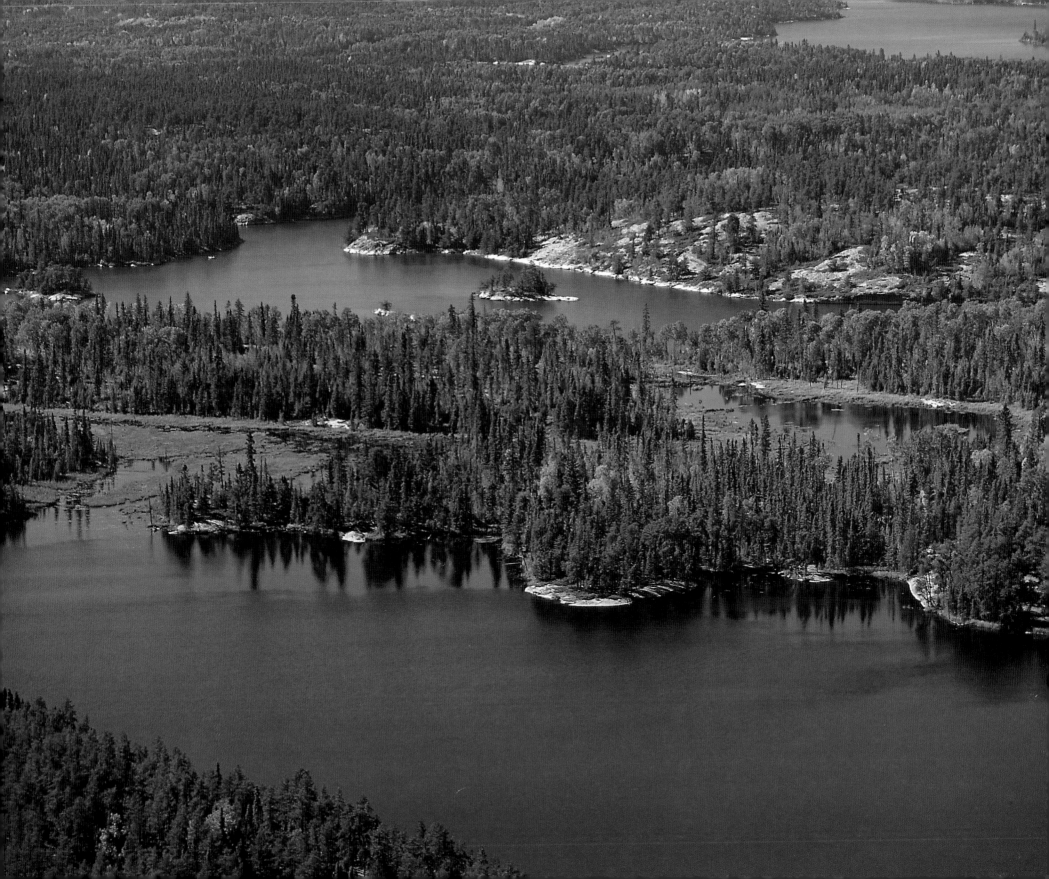

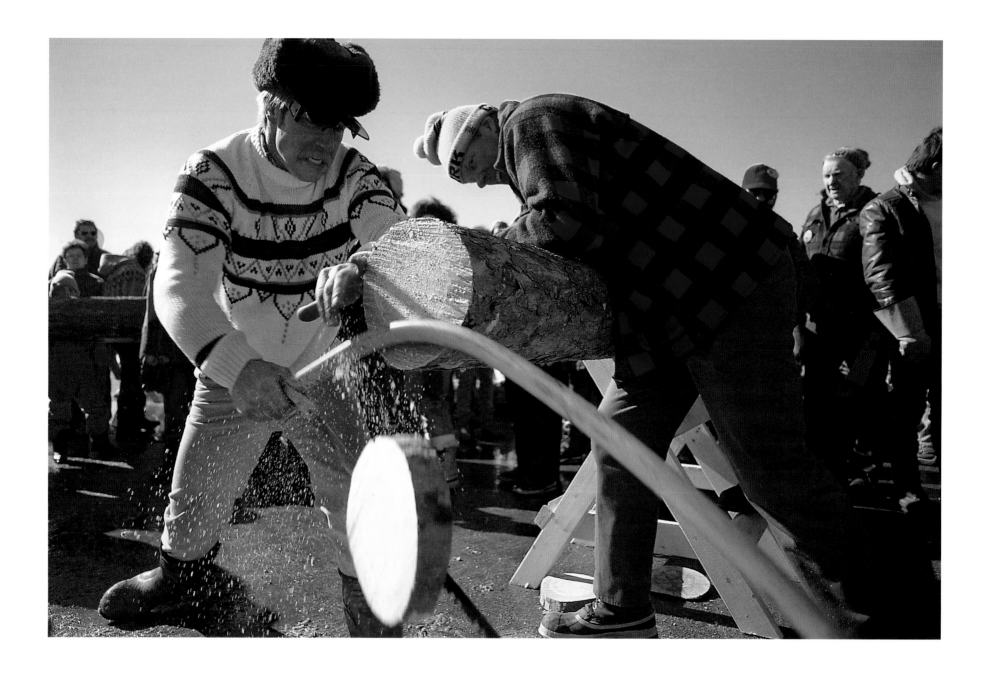

Celebrations abound in the north. Summer or winter we show off our culture, history and the ways we make our livings. Events like this can lead to some great pictures. The determination of a logger or the colourful costumes of ethnic dancers can be captured in a fraction of a second.

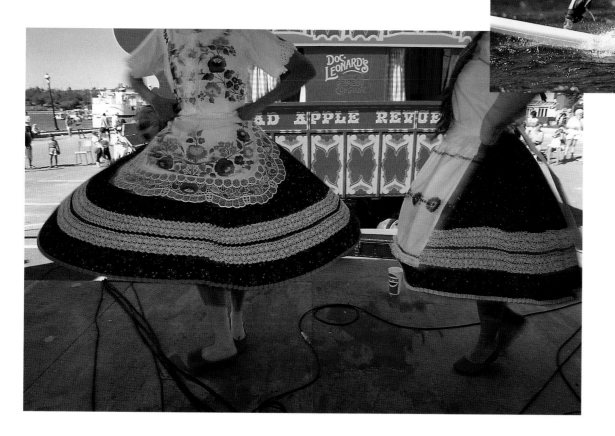

Grabbing the wind this person, like many others, has found their own way to pull as much enjoyment out of the waters as possible.

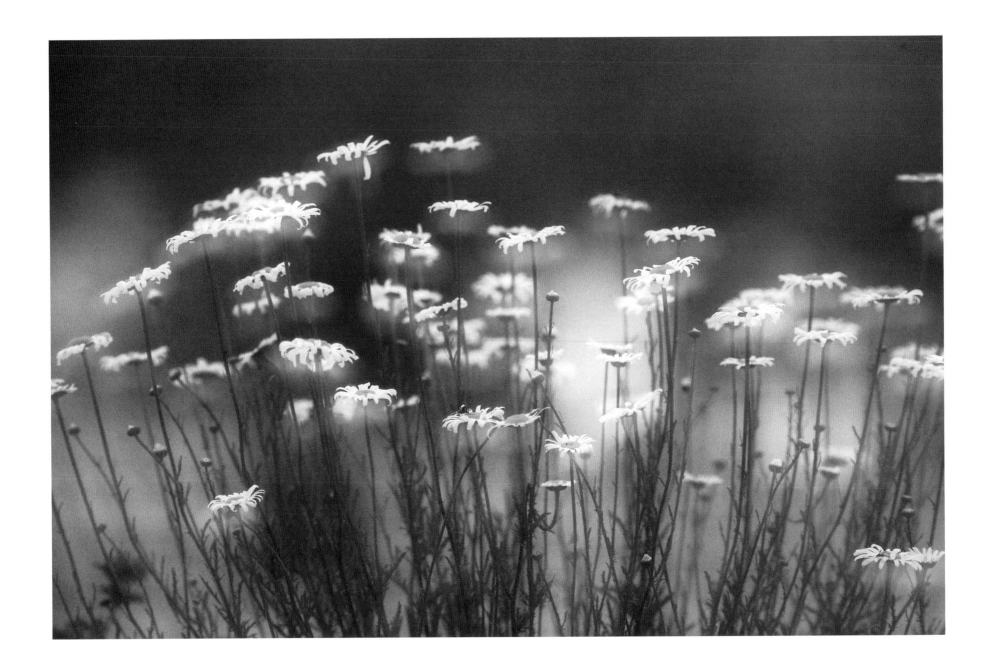

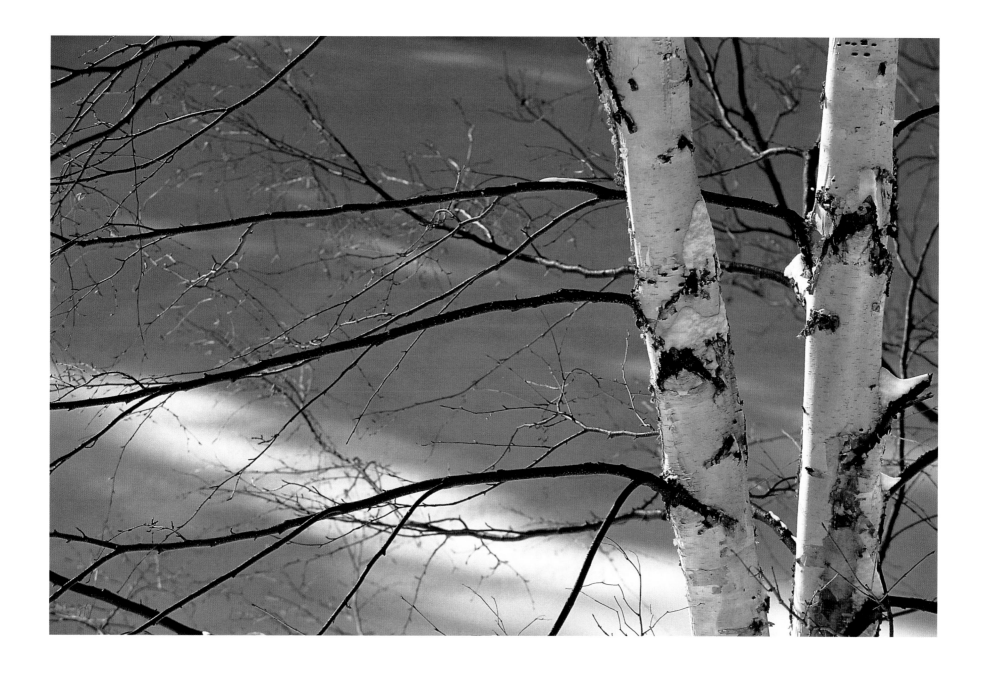

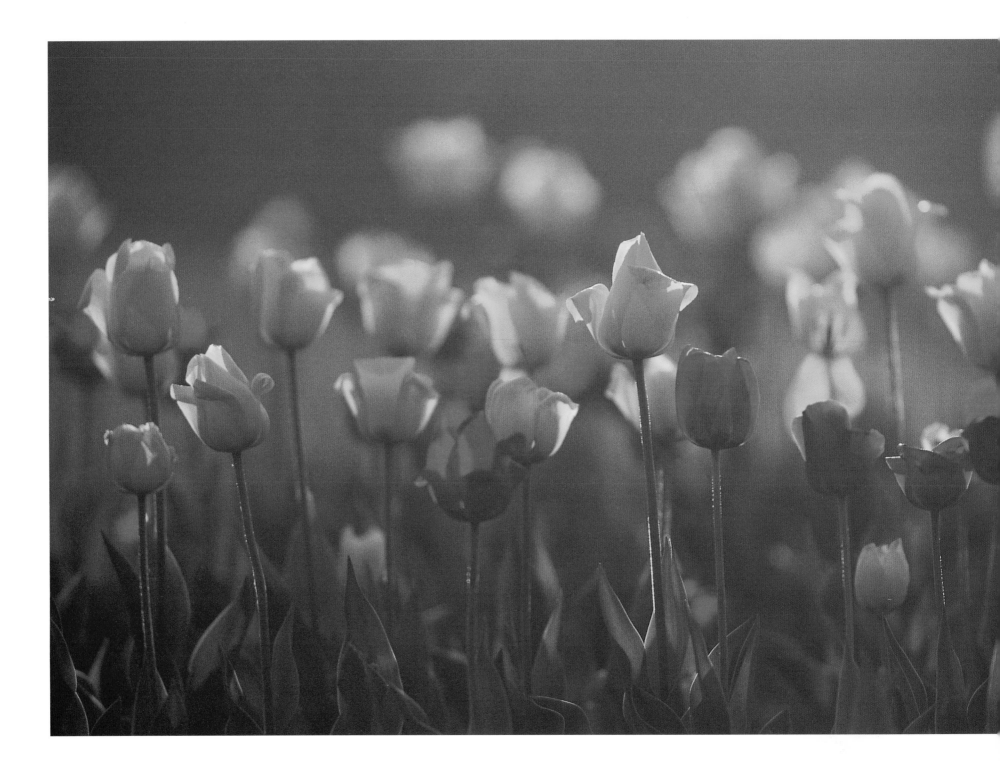

perspective

What you take from the north is usually based on what you bring to it, from your attitude, to the way you choose to view it. By bringing an open mind to your experiences with the north you can leave with a whole new feeling and appreciation for nature. When shooting pictures I always try to put this into play and will come away with a fresh look to the ordinary.

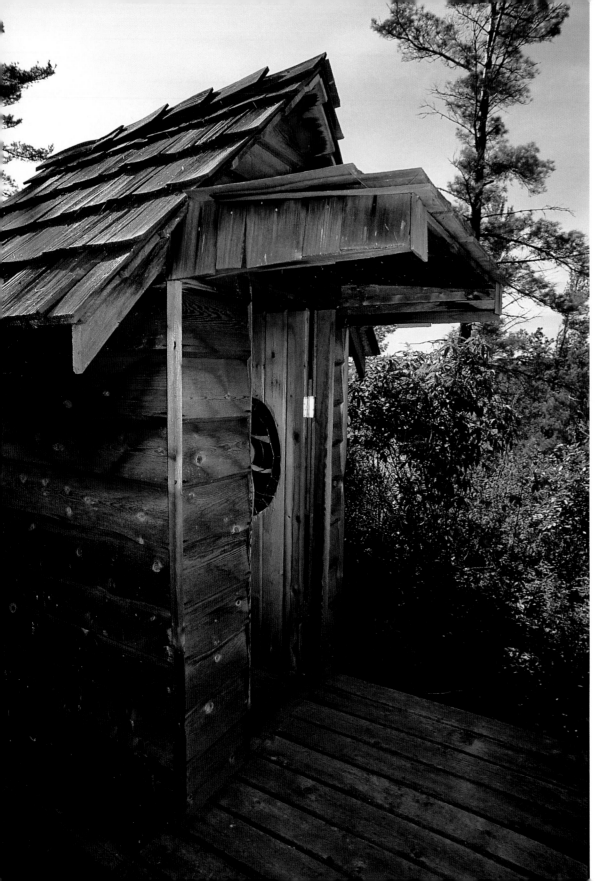

Outhouses and outbuildings
in their various forms can be
as interesting as nature itself.
From an outhouse with a
view of approaching visitors
through a stained glass
window to the boathouses
that have seen better days,
they all speak of their uses
and their owners.

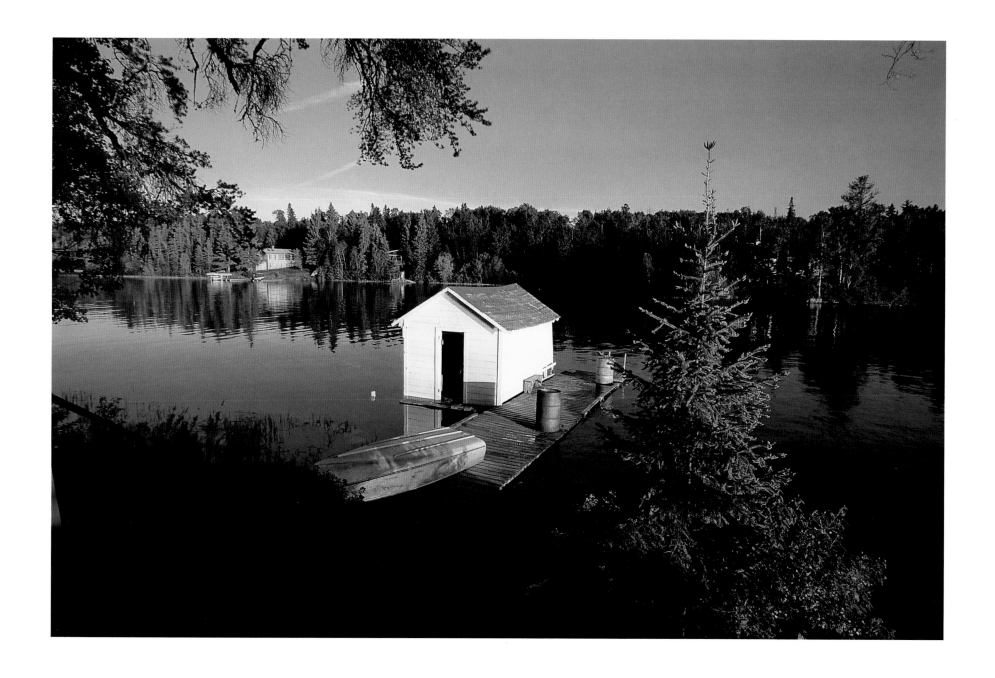

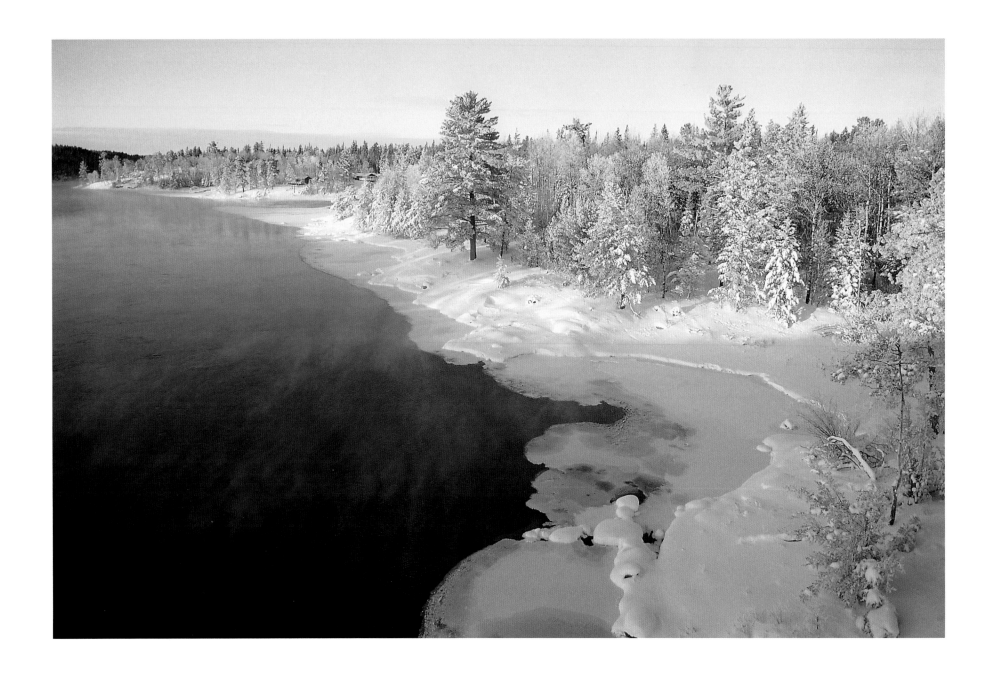

Fresh snowfall makes everything look so pristine and pure. I try to get out and shoot as soon as I can afterwards; the pictures seem to evoke a newness to the landscape. From a broad landscape to a tuft of grass, winter offers great opportunities for photos and all sorts of outdoor activities.

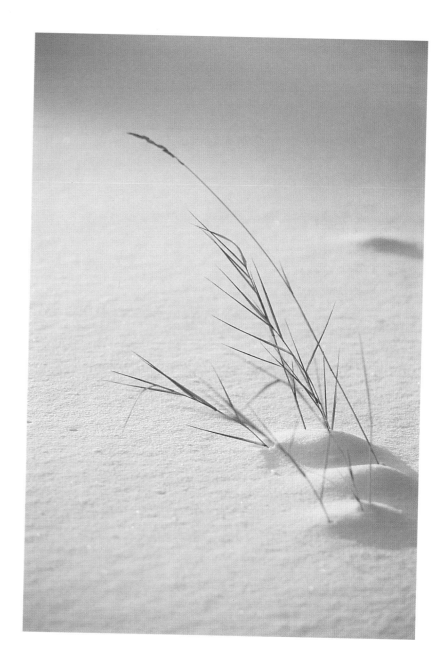

The image of solitude and quiet is what attracts so many people to the waters of Northern Ontario. For many people owning a piece of paradise for their weekend getaways is worth every penny spent to achieve it. Even cutting the lawn at the cottage doesn't seem as much a chore as it does at home.

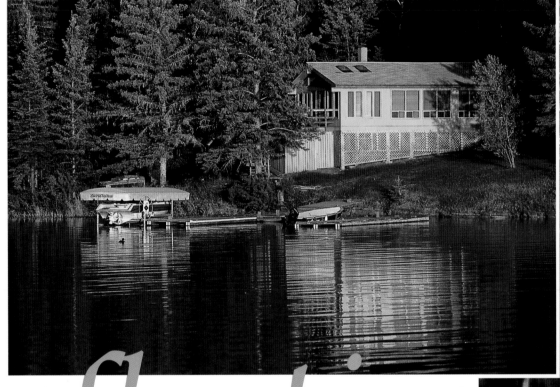

reflections

When the waters open up from the icy grip of winter people begin to get out more and take to the waters again. While the colours may be drab I find there is a lot of opportunity to shoot pictures of wildlife (and people) as they become more active. This picture works well because of the lack of leaves which helps create the strong vertical pattern reflected in the water.

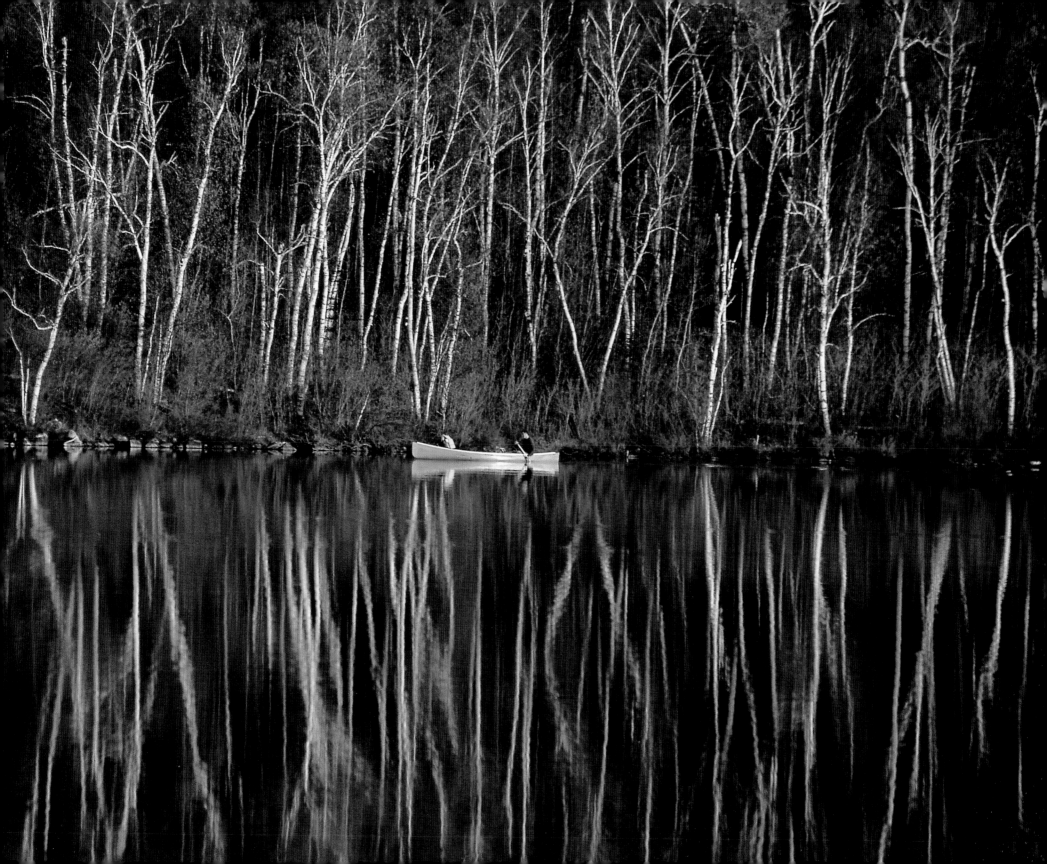

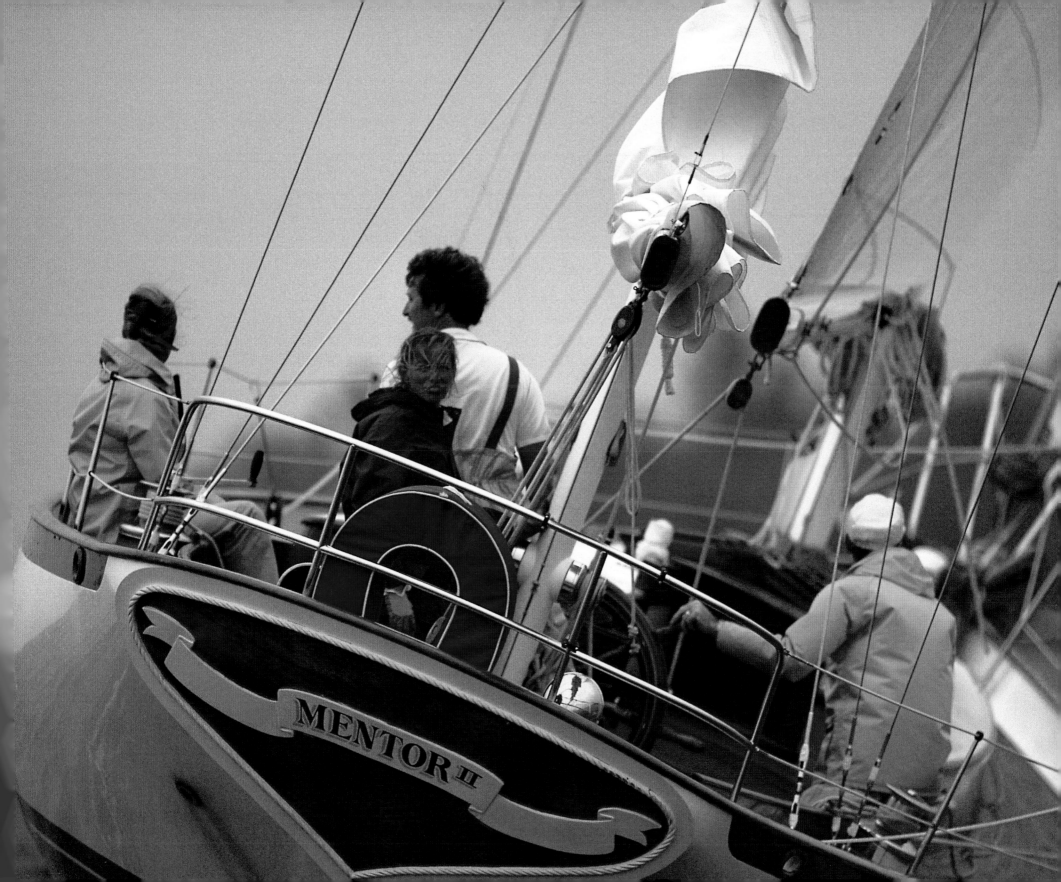

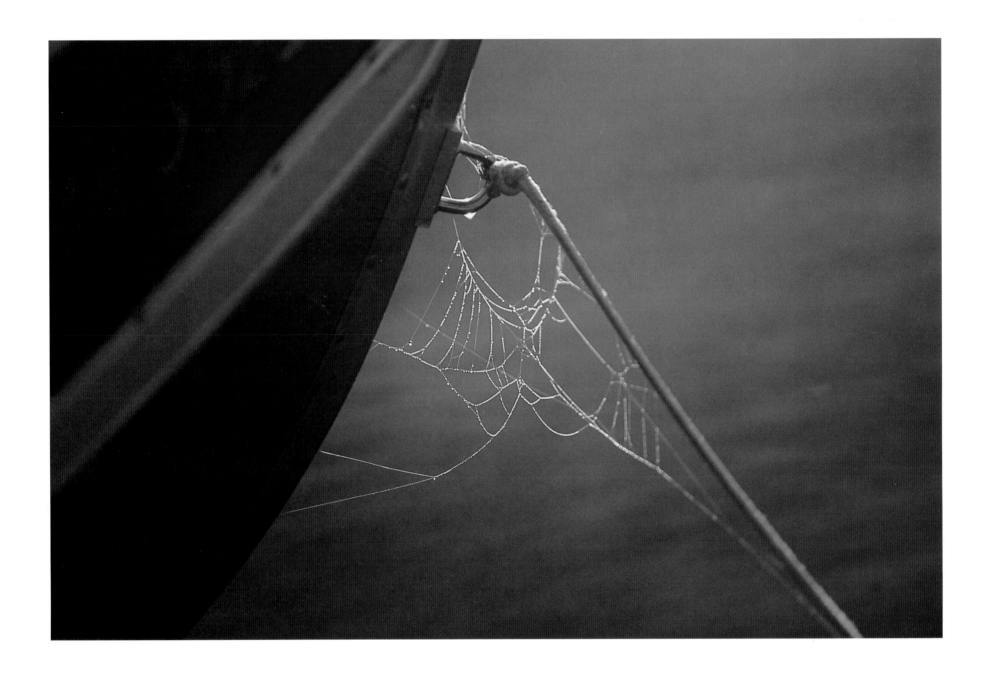

serenity

Time out is a rare luxury.

The still of the night is reflected in the fact that a spider was able to build this web. The calm waters allowed for uninterrupted construction. Unfortunately it didn't last. Each new day brings promise and sometimes disappointment.

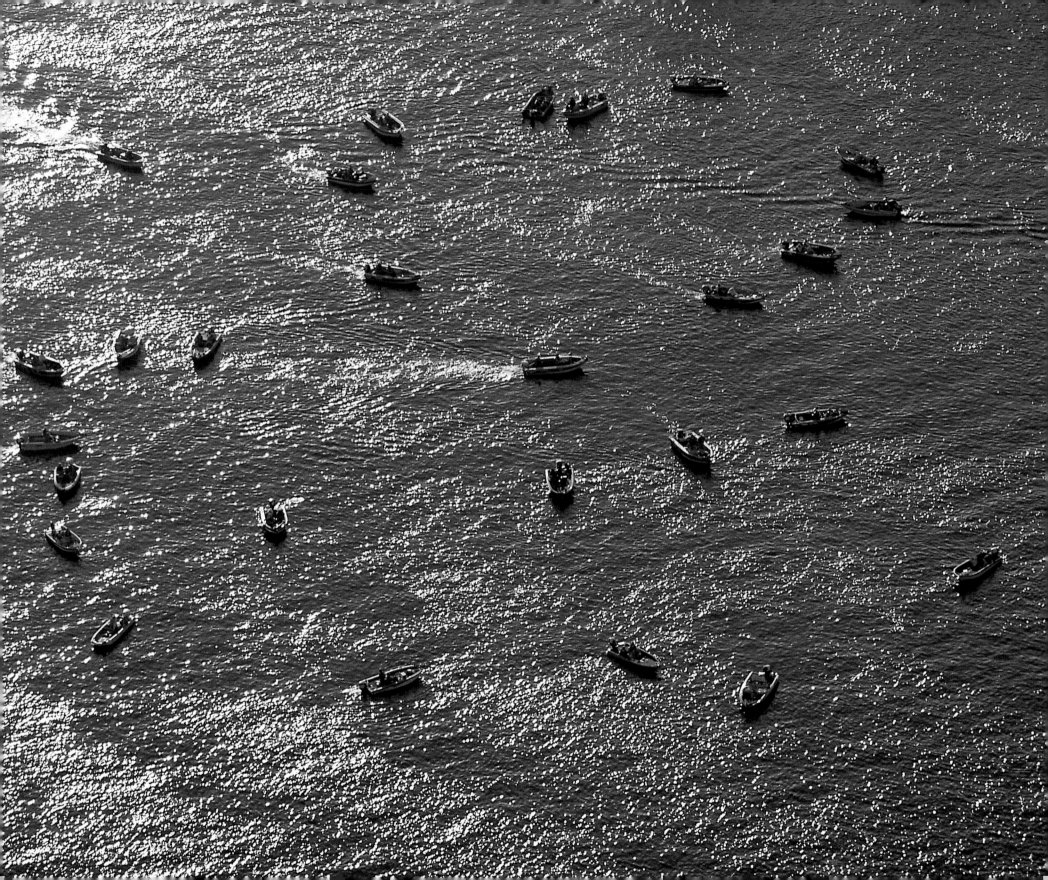

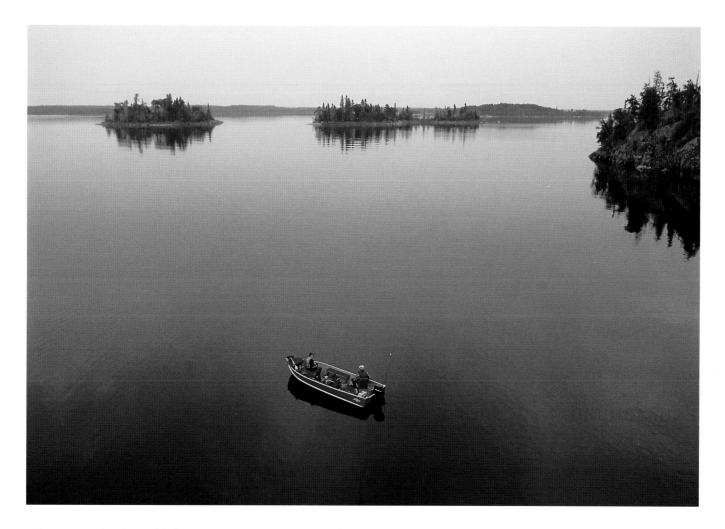

The start of a day of fishing is a joint venture for the boaters
awaiting the start of a fishing tournament at left. The days
end is a singular experience for the fishermen above.

Mother Nature provides us with the setting for those tranquil moments, to gather our thoughts or de-stress after a long day. All can appreciate the calmness that washes over us when we are enveloped in this serenity. The colors of the sky, water and earth change subtly as the hours go by. Just to sit and watch the evening sun set is a gift. The patterns and rhythms of nature reinforce its bond with us allowing us to unwind. Whether cruising the lake and enjoying the shoreline that changes with the seasons, or watching the wildlife and their intriguing timeless rituals.

 . . . it is all here.

tranquility

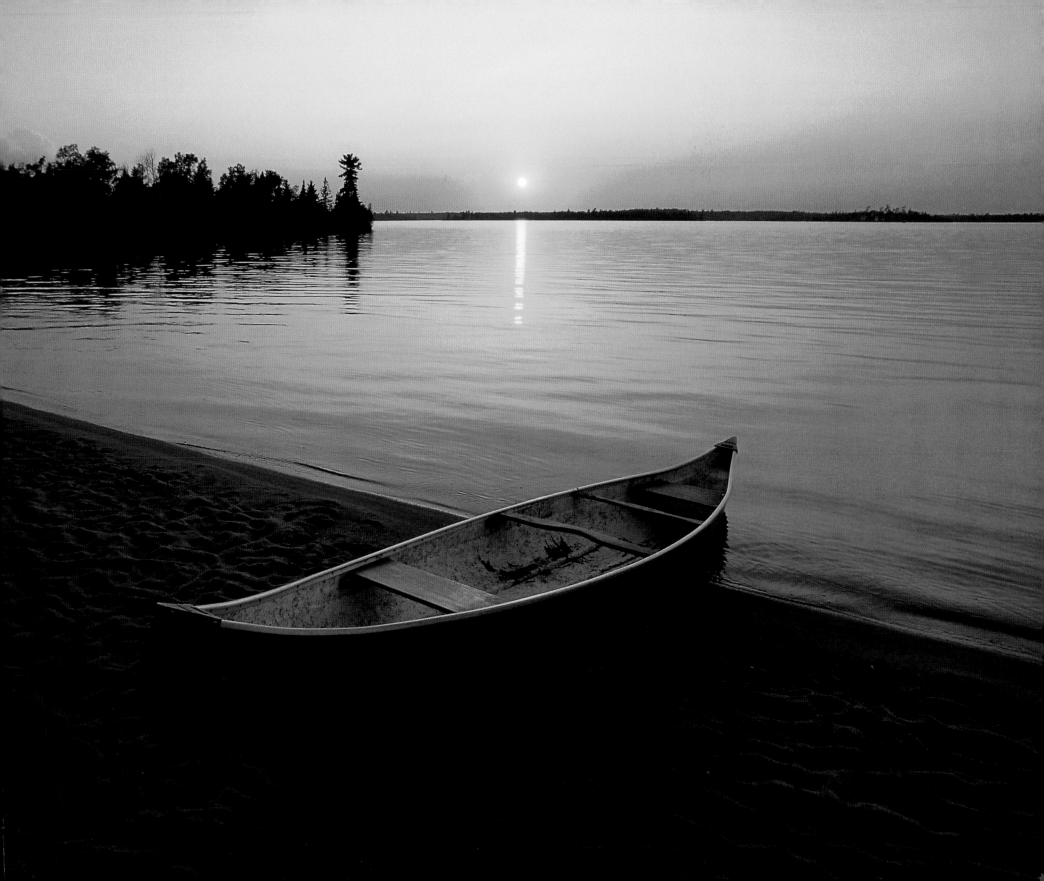

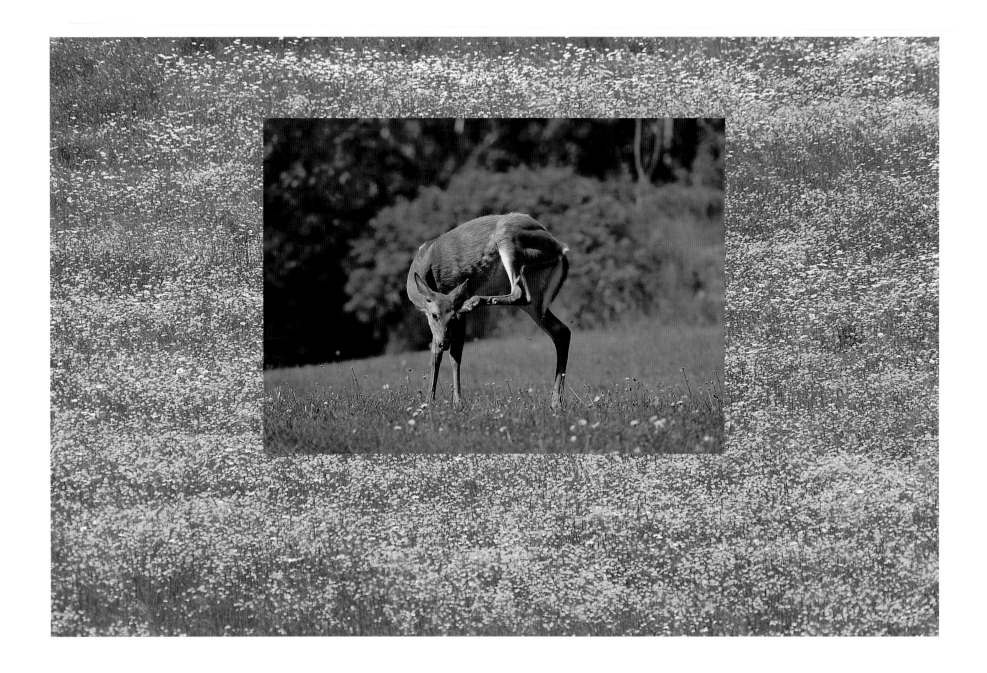

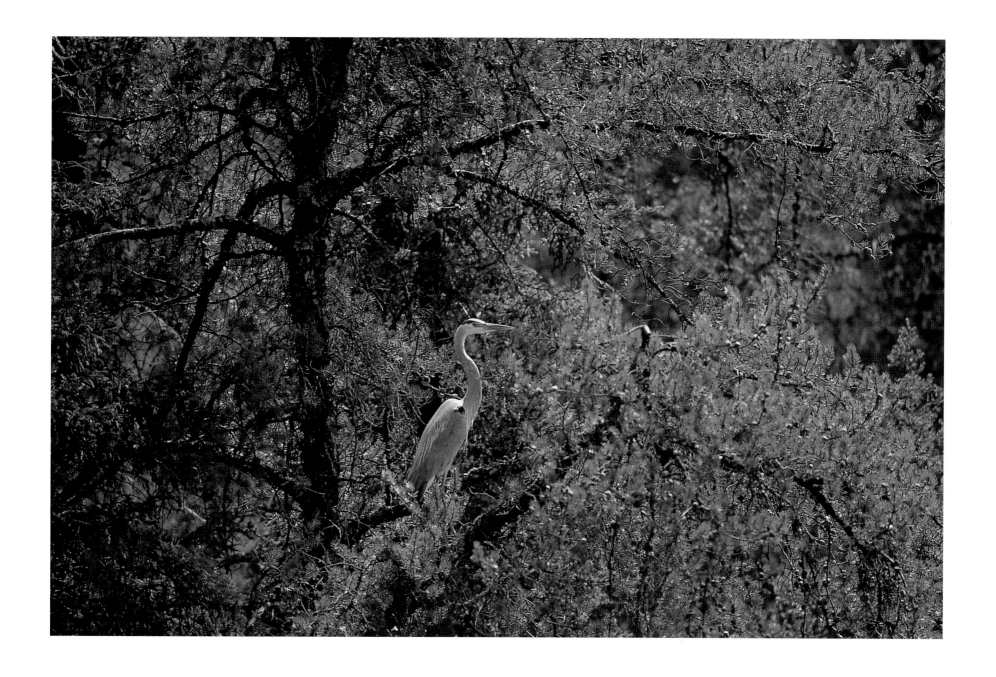

When I was a guide some of the guests would remark on how the trees could grow seemingly right out of the rock, while they had trouble growing corn with ten feet of topsoil.

The last remnants of daylight provides the perfect setting to try your luck and shoot the breeze till sunset. I will always remember fishing with my father on evenings just like this.

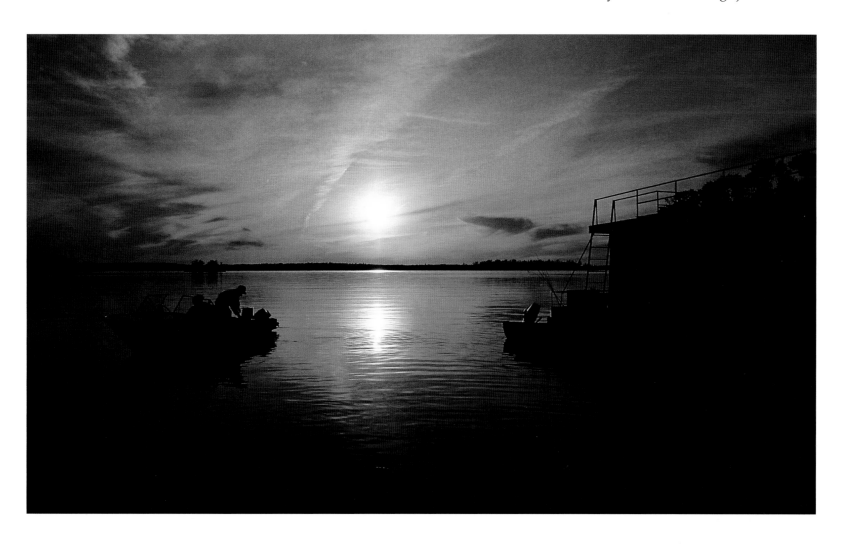

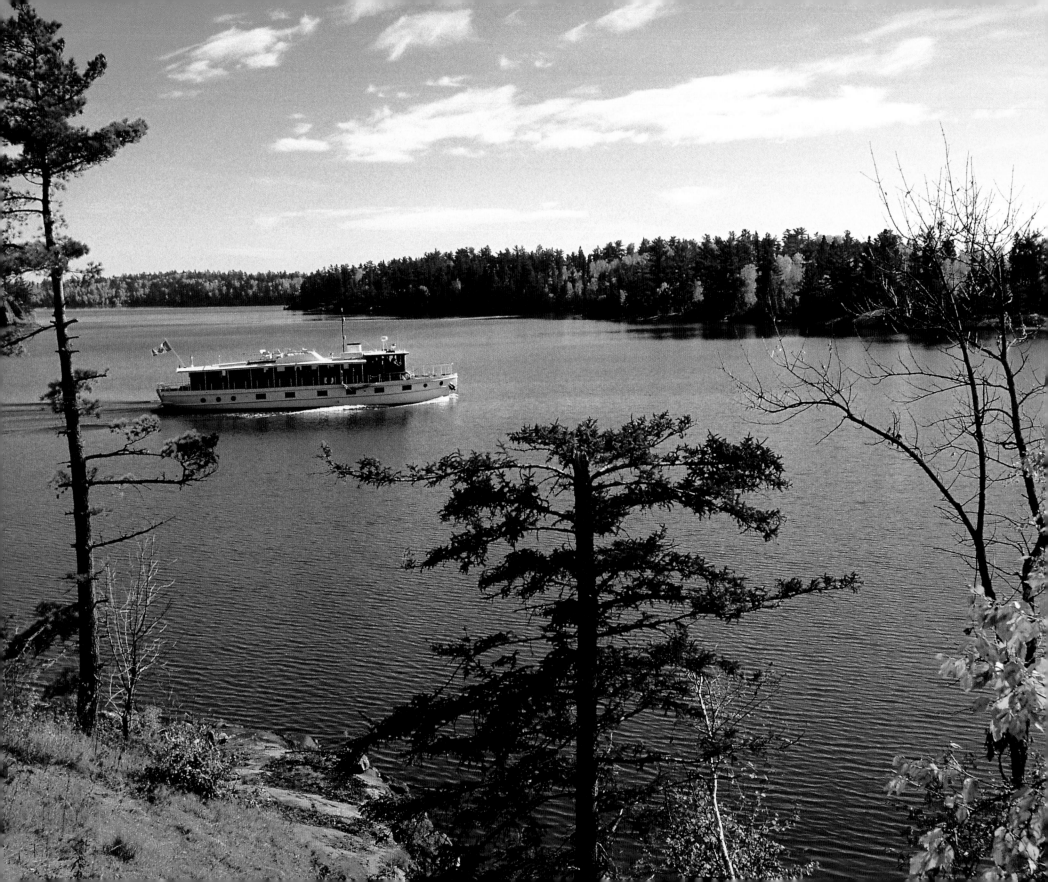

Classic wooden boats still ply the waters of many a Northern Ontario lake. During their heyday they were used to haul freight and as pleasure craft.

Packing up for the winter for a lot of people, means hauling things back to town by barge. With such vast amounts of water to traverse the only way to get things such as building supplies where they need to go is by barging. I once attended a wedding on an island and they floated in the caterers, five ton truck and all.

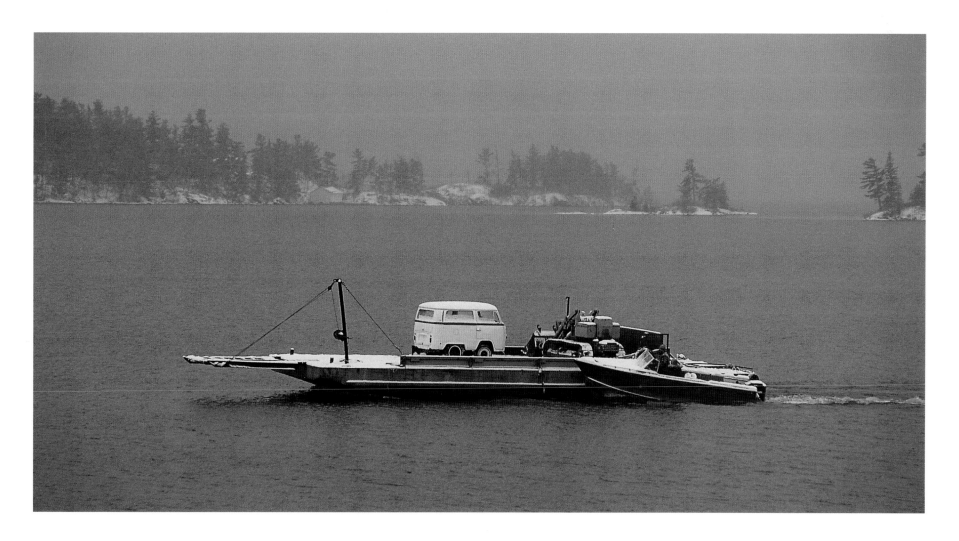

escape

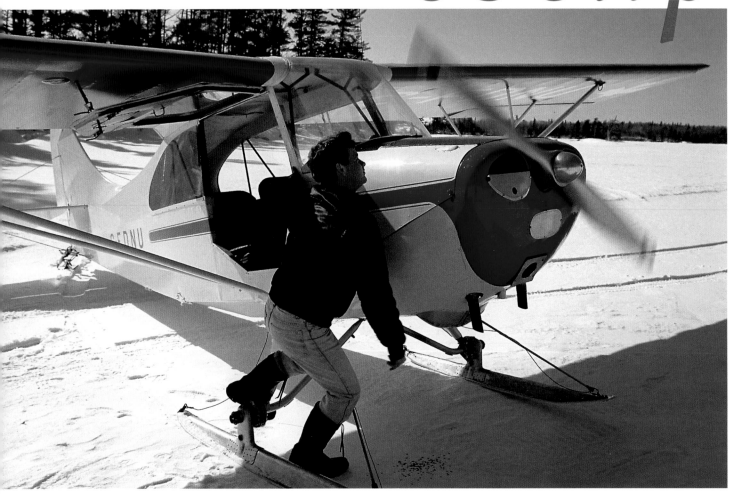

Riding aloft in a plane can be an almost spiritual experience. As you look down at the endless miles of forbidding landscape it is hard to imagine how this area could ever have been settled. With the advent of modern transportation such as the snowmobile, crossing these great stretches of wilderness has become a form of recreation and a way to escape.

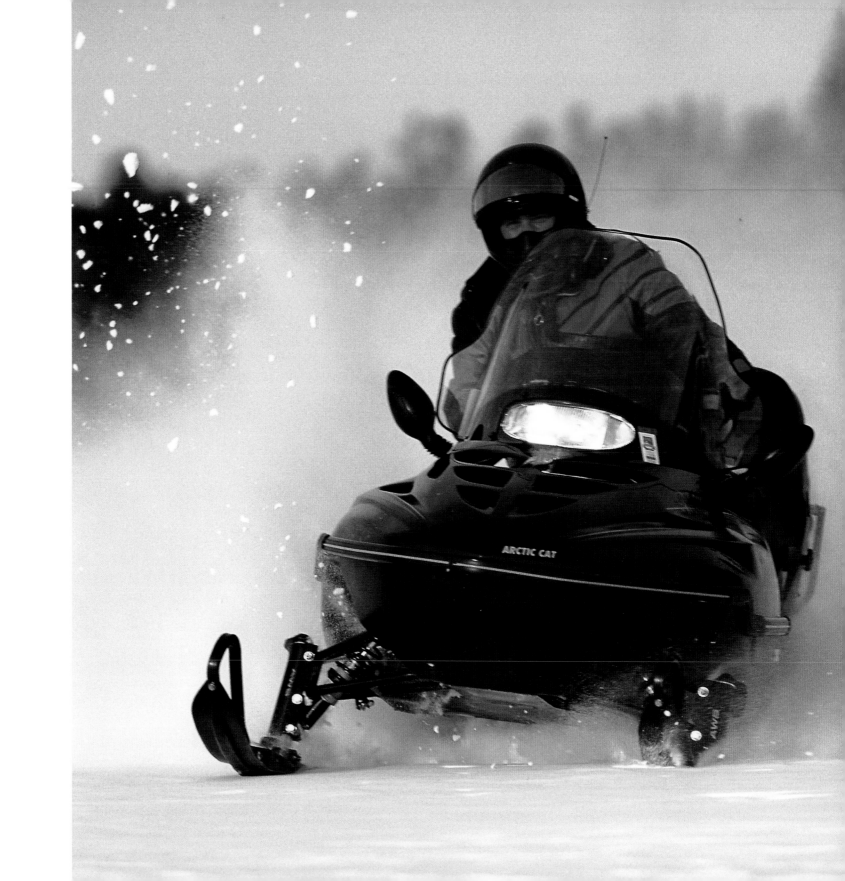

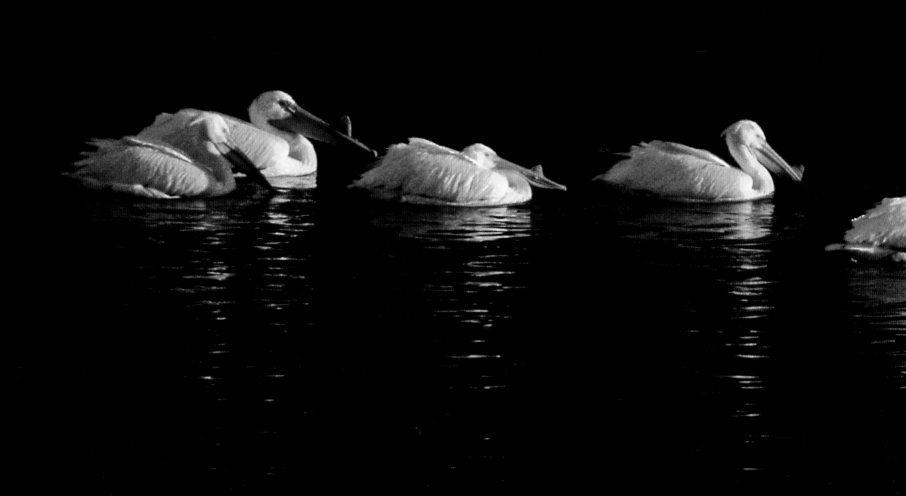

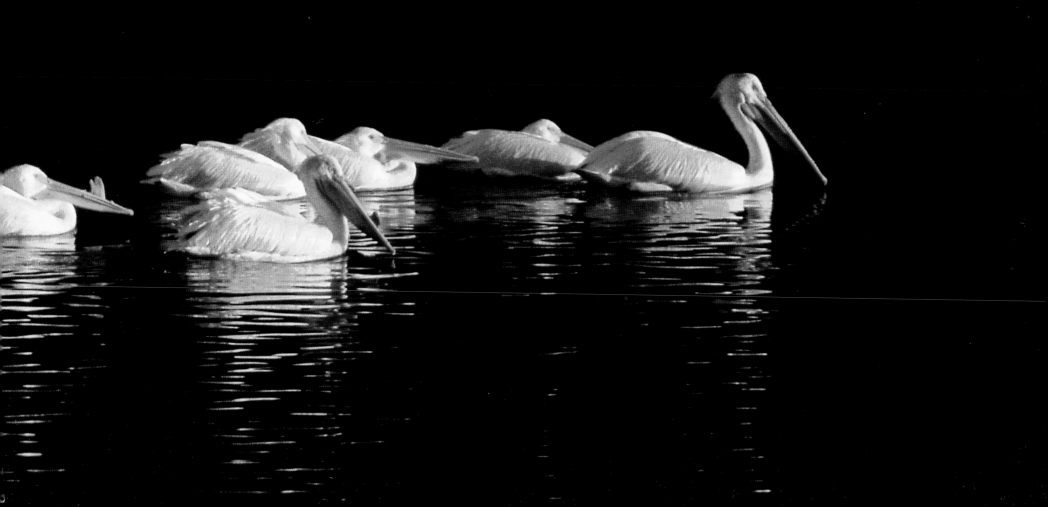

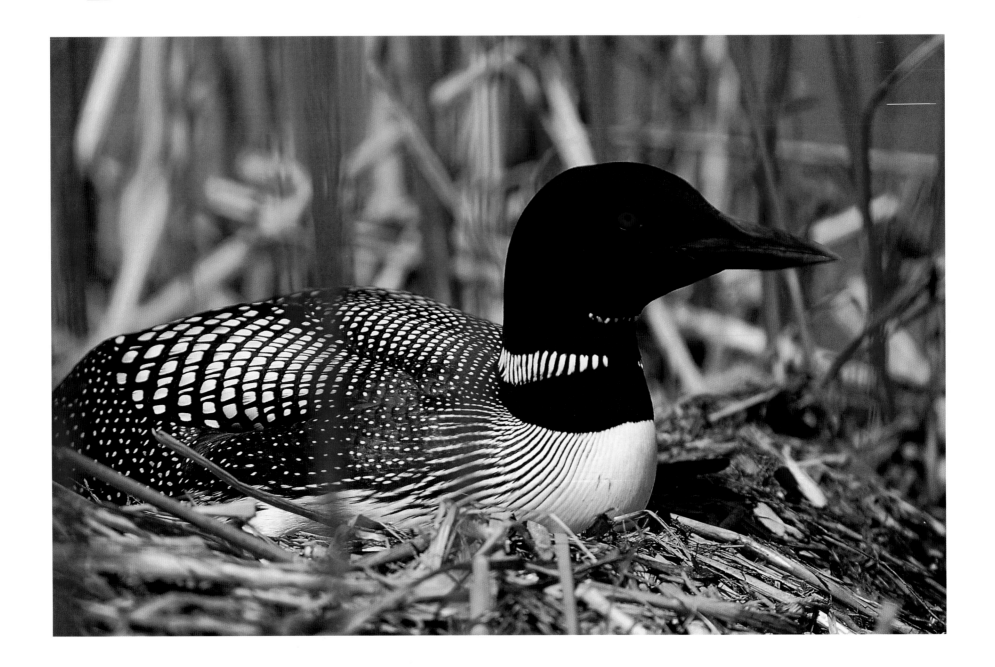

Native legend tells that the loon once had the most beautiful song of all birds. One day evil spirits captured the sun and locked it in a box, so that the world turned cold and dark. The brave loon attempted to rescue the sun and barely survived her battle with the spirits. Her voice was irrevocably damaged. She was left with only the sad, lonely call we hear today.

The call of the loon at sunset
can be heard for miles.

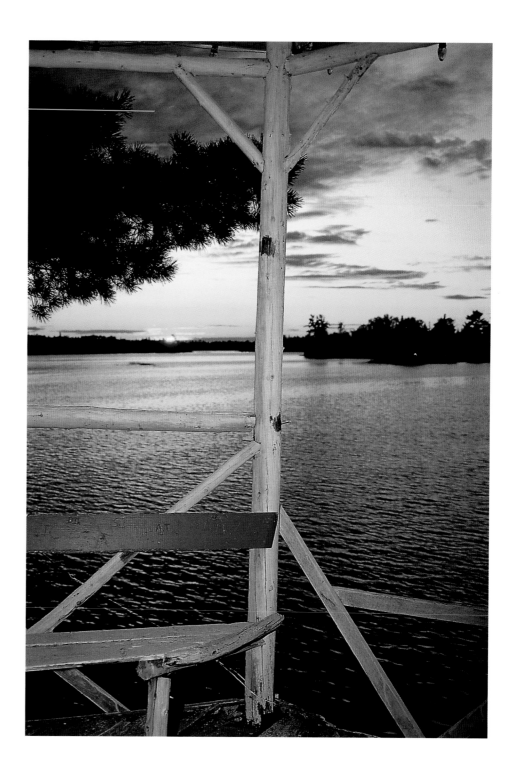

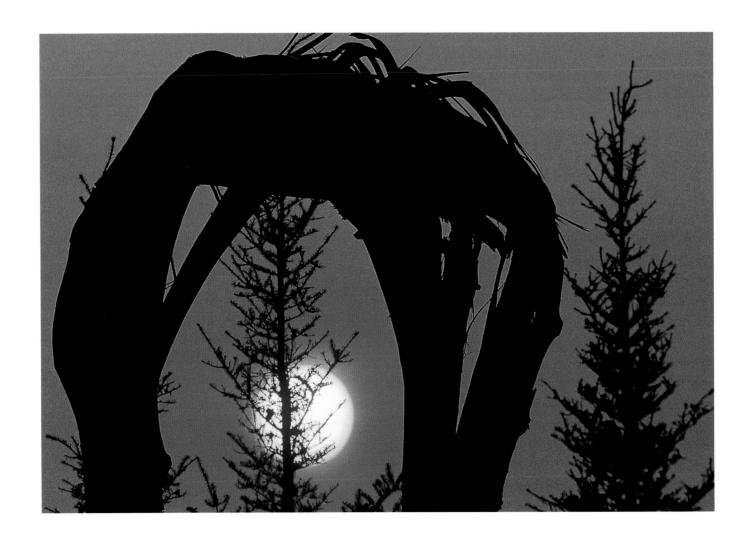

While on assignment to shoot a story about the devastation caused by a wind storm I noticed this tree twisted into an abstract shape by the fierce winds. Making a mental note of the location I returned near sunset and waited until all the elements came together to create this intriguing photo. Out of nature's destruction can come beauty.

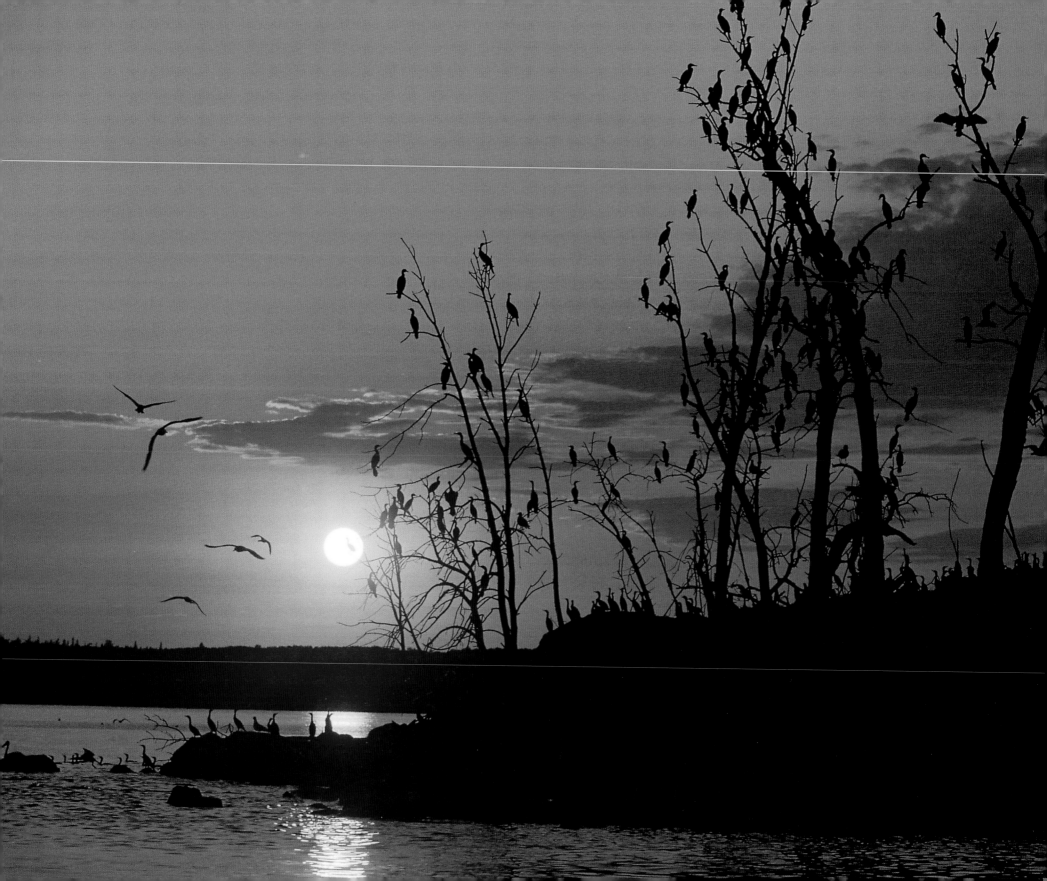

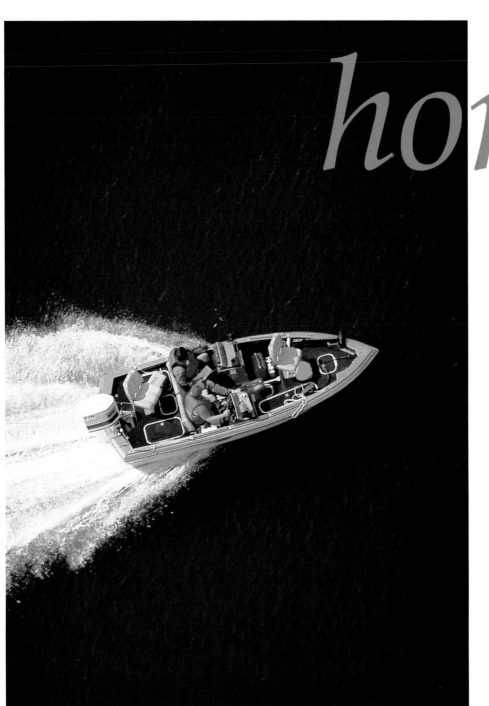

horizon

B oating along a peaceful shoreline, hearing the soft hum of the motor, taking in the pungent aroma of algae and water, trees, flowers, and moss, wafting through the air; we can truly appreciate our surroundings. A soft breeze gently caressing your hair, sun warming your skin; these are the moments we remember as we get older. They become precious to us, as if forever frozen in the album of our memories. We never forget "the big one that got away", we tell the story as if it happened yesterday.

These memories are ones which we are privileged to own, and we as individuals should make an effort to pass this on to future generations. With the advance of technology, the speed at which we can travel over water and land has become much faster than in years gone by. We now can get to those small, secluded lakes teeming with life in moments rather than hours. We are exploring deeper into our lakes, rivers and forest where few humans have ever been. What a wonderful feeling to return with your limit and the memories of the ones released to the deep unknown again.

We have been given a gift that should be preserved and protected so that our children and grandchildren will have a chance to cultivate beautiful memories, just as we have..

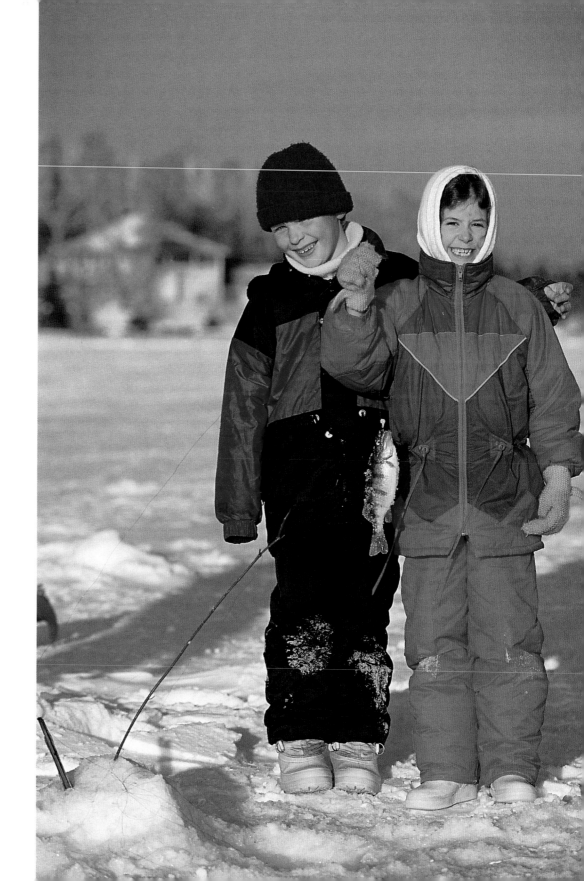

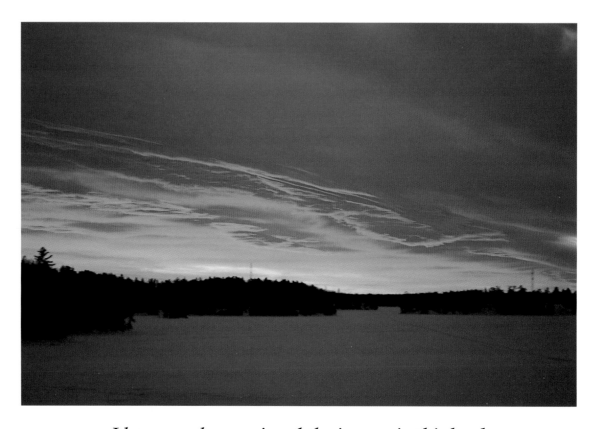

I hope you have enjoyed the images in this book
as much as I have enjoyed sharing them with you.

We welcome you to visit our website at www.voyageur.ca/~tthomson